THE MASTER GUIDE TO DRAWING ANIME
ROMANCE

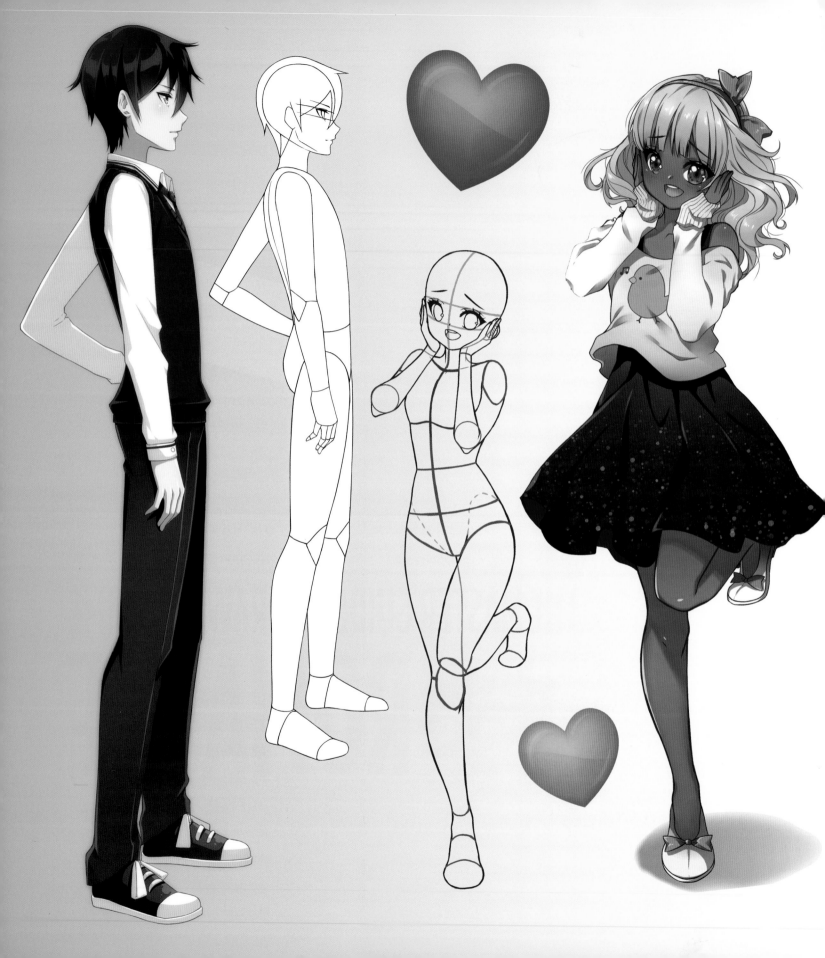

DRAWING WITH *Christopher Hart*

THE MASTER GUIDE TO DRAWING ANIME
ROMANCE

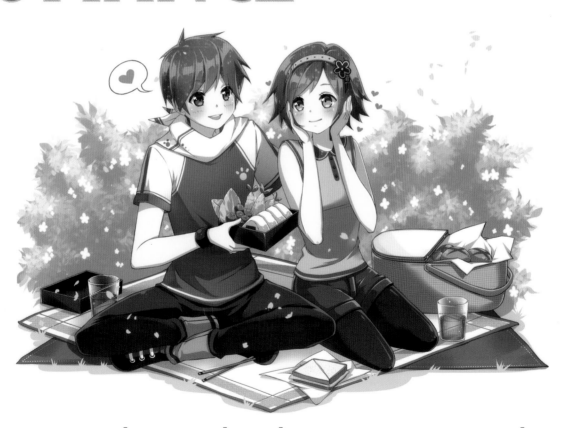

How to Draw the Popular Character Types Step by Step

Get Creative 6

DRAWING WITH *Christopher Hart*

An imprint of **Get Creative 6**
104 West 27th Street, New York, NY 10001
Sixthandspringbooks.com

Editor
LAURA COOKE

Art Director
IRENE LEDWITH

Contributing Artists
AKANE
ANZU
ERO-PINKU
KAGURA
NACHOZ
SHOUU KUN
SUGAR MIKI
TABBY KINK

Chief Executive Officer
CAROLINE KILMER

President
ART JOINNIDES

Chairman
JAY STEIN

Caution: Children should only use child-safe art supplies.

Library of Congress Cataloging-in-Publication Data
Names: Hart, Christopher, 1957- author.
Title: The master guide to drawing anime: romance : how to draw popular character types step by step / Christopher Hart.
Description: First edition. | New York : Drawing with Christopher Hart, 2020. | Series: The master guide to drawing anime | Includes index. |
Identifiers: LCCN 2019056522 | ISBN 9781684620012 (paperback)
Subjects: LCSH: Comic books, strips, etc.--Japan--Technique. | Cartooning--Technique. | Figure drawing--Technique. | Comic strip characters.
Classification: LCC NC1764.5.J3 H36947 2020 | DDC 741.5/8--dc23

2019056522

Manufactured in China

1 3 5 7 9 10 8 6 4 2

christopherhartbooks.com
facebook.com/CARTOONS.MANGA
youtube.com/user/chrishartbooks

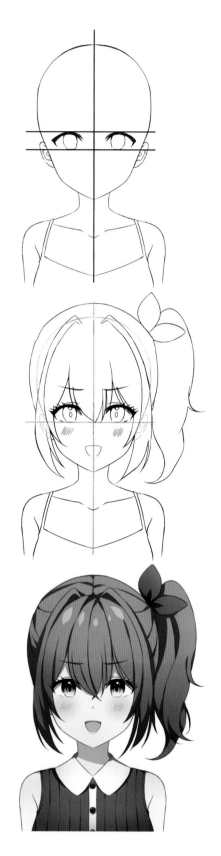

To aspiring anime artists everywhere!

Contents

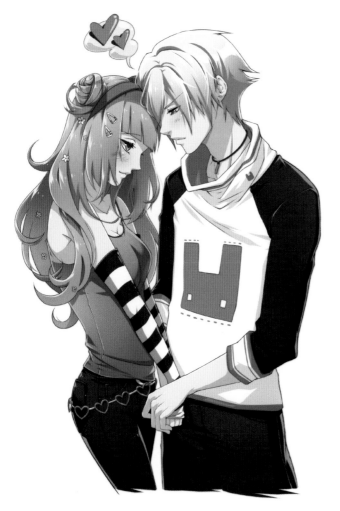

Introduction

Romance is one of the most exciting genres of anime. It features an array of popular characters and personalities, which you can learn to draw. The plot lines are compelling, and they give fans everything they want, from breakups and makeups to loyal friends and bitter rivalries.

Romance characters are often locked in a dramatic tug of war between those who are popular and those who want to be. With emotions running high, romance characters can be unpredictable. Some are cute or funny while others are anxious or possessive. We'll start off by drawing individual characters, then we'll progress to drawing two characters together to create simple scenes. You'll learn the tricks to creating a mood by adjusting the visual elements of a scene. Then I'll introduce the specialty genres, such as fantasy and mystery romance. They bring exciting visual effects and twists to romance concepts.

As with every book in the Master Guide series, the drawing instruction is simplified with easy-to-follow steps. There are no gaps from one step to the next. They gradually build on each other, allowing you to create finished drawings with ease. So join in the comedy and drama that make up the romance genre of anime. The lessons are practical and entertaining. Let's get started!

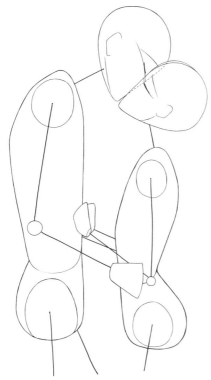

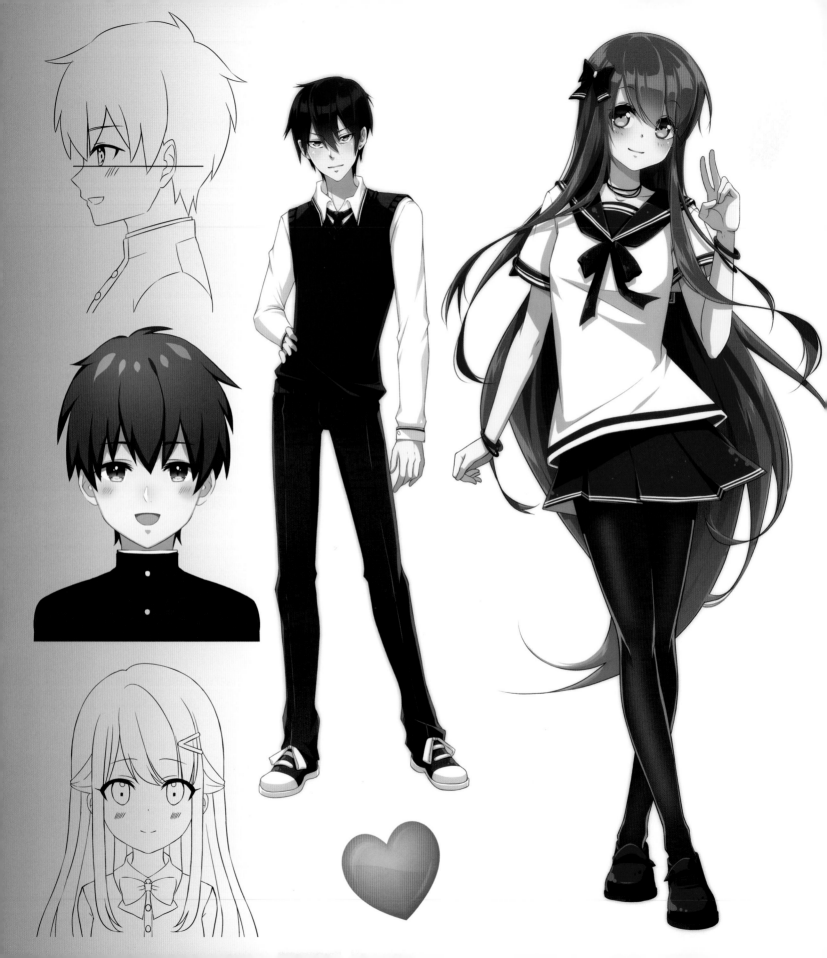

Drawing the Anime Head and Body

We'll begin by drawing the head from the front and side views, then we'll learn the basics of drawing the body, also from the front and side views. Using guidelines will help you establish the basic proportions and provide you with an accurate framework from the start. This approach will free you up to focus on the details and finishing touches—like eye-catching hairstyles and clothing—that are specific to the anime style and fun to draw.

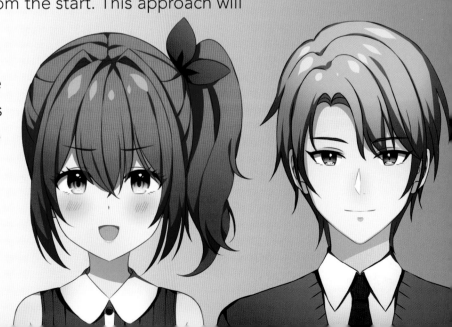

Middle School Girl—Front

Middle school represents the "between" years, when a character isn't a kid anymore but isn't quite a teenager either. There are many popular anime characters in this age range. The basic look for middle school characters is cute and shy. Notable features to look for are simplified, pronounced eyes with heavy eyelids; a dot for the nose (in the front view); a subtle mouth; and profuse hair.

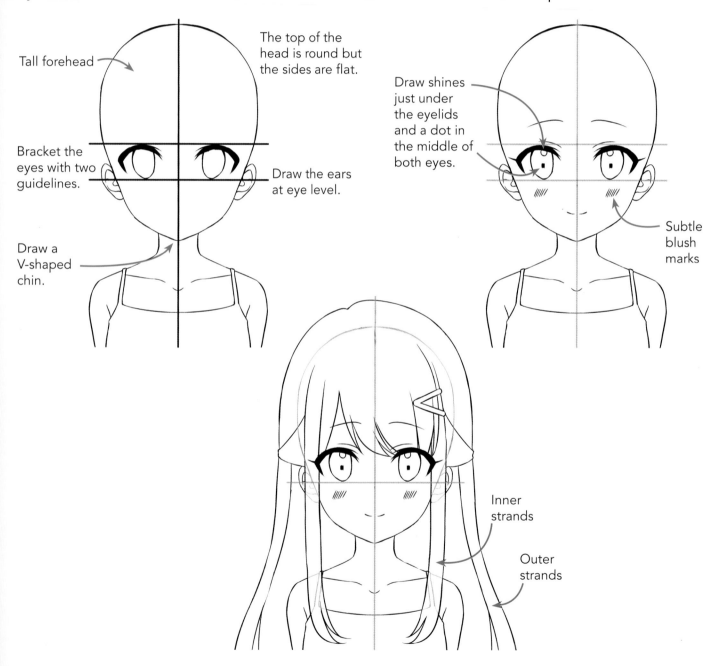

Tall forehead

The top of the head is round but the sides are flat.

Bracket the eyes with two guidelines.

Draw the ears at eye level.

Draw a V-shaped chin.

Draw shines just under the eyelids and a dot in the middle of both eyes.

Subtle blush marks

Inner strands

Outer strands

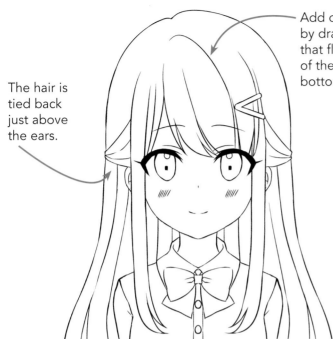

The hair is tied back just above the ears.

Add detail to the hair by drawing strands that flow from the top of the head to the bottom of the bangs.

A buttoned-up shirt with a bow is the beginning of a school uniform—a famous outfit for teen anime characters.

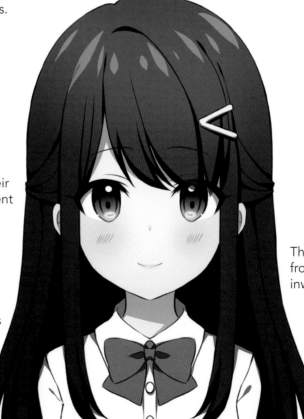

The eyes are drawn at the center of the head, which contributes to their being the most prominent feature of the face.

The long strands in front of the ears curl inward at the bottom.

Younger characters have narrower shoulders.

13

Middle School Girl—Side

The side view, also referred to as the profile, is a good angle for drawing a character who is talking to someone or watching something happen. All of the contours happen on the front of the face, from the bridge of the nose to the tip of the chin. That's your main focus. Once you've got that covered, the rest is easy.

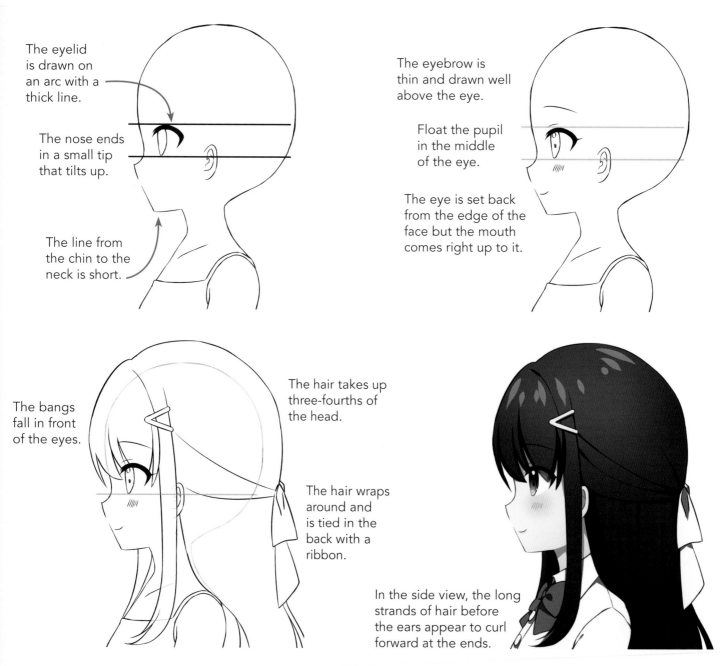

The eyelid is drawn on an arc with a thick line.

The nose ends in a small tip that tilts up.

The line from the chin to the neck is short.

The eyebrow is thin and drawn well above the eye.

Float the pupil in the middle of the eye.

The eye is set back from the edge of the face but the mouth comes right up to it.

The bangs fall in front of the eyes.

The hair takes up three-fourths of the head.

The hair wraps around and is tied in the back with a ribbon.

In the side view, the long strands of hair before the ears appear to curl forward at the ends.

High School Girl—Front

The high school girl's face is slightly longer than that of the middle schooler. The jawline is more angular, and the eyes are less round and more horizontal. Her hair is livelier, and its color, red, reflects a bolder attitude. This type of character has expressive eyebrows that she uses when she tells her friends the newest gossip she just heard.

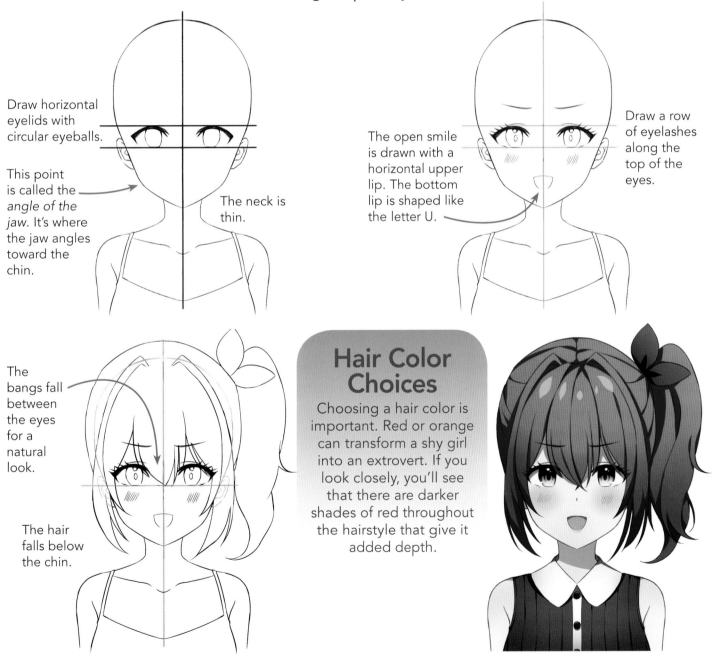

Draw horizontal eyelids with circular eyeballs.

This point is called the *angle of the jaw*. It's where the jaw angles toward the chin.

The neck is thin.

The open smile is drawn with a horizontal upper lip. The bottom lip is shaped like the letter U.

Draw a row of eyelashes along the top of the eyes.

The bangs fall between the eyes for a natural look.

The hair falls below the chin.

Hair Color Choices

Choosing a hair color is important. Red or orange can transform a shy girl into an extrovert. If you look closely, you'll see that there are darker shades of red throughout the hairstyle that give it added depth.

High School Girl—Side

From the side view, you can see the three major elements of the standard schoolgirl haircut: bangs, side strands, and pigtails (or one ponytail). Once you can draw this, you can create variations that work for many different character types and hairstyles.

The bridge of the nose is almost invisible in the front view, but it is prominent in the side view due to the deep curve.

When the eyebrows tilt slightly down, it reads as intense. If you tilted them any further, it would make her look angry.

The thick upper eyelid extends past the eyeball.

The tip of the nose flips up.

Draw extra long bangs *below* the eyes!

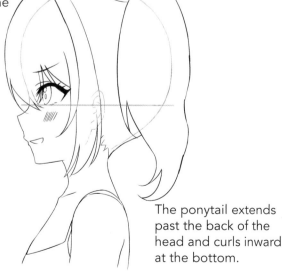

The ponytail extends past the back of the head and curls inward at the bottom.

There are yellow highlights at the front of her head caused by overhead light.

A neutral color, like the gray of her shirt, works well in combination with a bolder color like red.

Middle School Boy—Front

The middle school boy has a friendly, good-natured appearance that is created with a head full of hurriedly combed hair, big eyes, and a small chin. The nose and mouth are reduced in size, and the ears are small too.

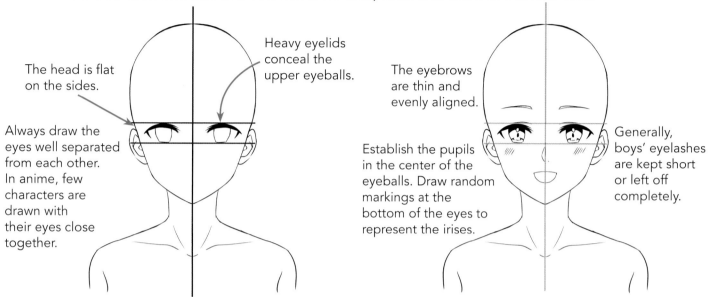

The head is flat on the sides.

Heavy eyelids conceal the upper eyeballs.

Always draw the eyes well separated from each other. In anime, few characters are drawn with their eyes close together.

The eyebrows are thin and evenly aligned.

Establish the pupils in the center of the eyeballs. Draw random markings at the bottom of the eyes to represent the irises.

Generally, boys' eyelashes are kept short or left off completely.

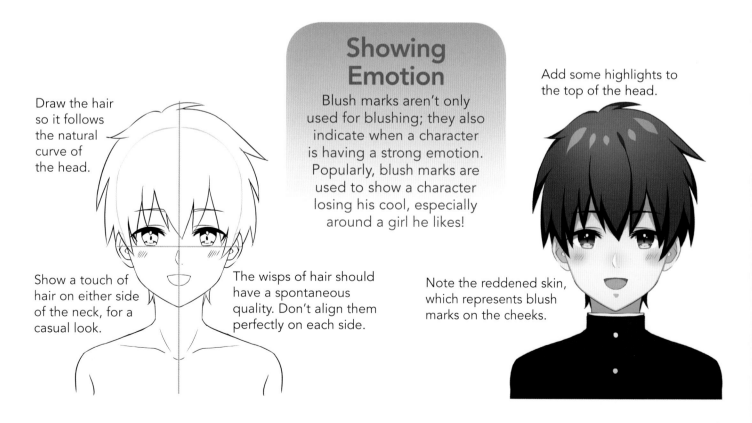

Draw the hair so it follows the natural curve of the head.

Show a touch of hair on either side of the neck, for a casual look.

The wisps of hair should have a spontaneous quality. Don't align them perfectly on each side.

Showing Emotion

Blush marks aren't only used for blushing; they also indicate when a character is having a strong emotion. Popularly, blush marks are used to show a character losing his cool, especially around a girl he likes!

Add some highlights to the top of the head.

Note the reddened skin, which represents blush marks on the cheeks.

High School Boy—Front

The high school boy's head is round on top but severely tapered at the chin, which gives his face a narrow appearance. The features are lightly drawn—except for the eyelids, which are jet black and elongated. The hair has a part hidden somewhere in there, if you can find it!

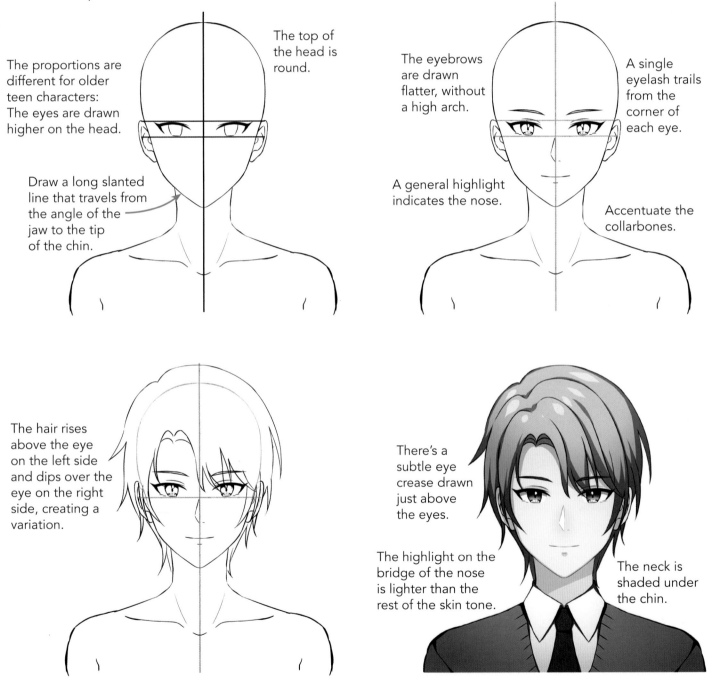

The proportions are different for older teen characters: The eyes are drawn higher on the head.

The top of the head is round.

Draw a long slanted line that travels from the angle of the jaw to the tip of the chin.

The eyebrows are drawn flatter, without a high arch.

A single eyelash trails from the corner of each eye.

A general highlight indicates the nose.

Accentuate the collarbones.

The hair rises above the eye on the left side and dips over the eye on the right side, creating a variation.

There's a subtle eye crease drawn just above the eyes.

The highlight on the bridge of the nose is lighter than the rest of the skin tone.

The neck is shaded under the chin.

Middle and High School Boy–Side

The basic principles of drawing the profile of anime boys are similar to those of anime girls. However, the angles tend to be more defined. Let's compare the looks on both middle school and high school boys.

YOUNG TEEN—SIDE VIEW

Natural, casual hairstyle

The eye is slightly larger and drawn lower on the face.

The point of the jaw is drawn low on the head.

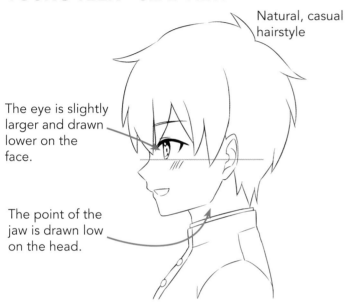

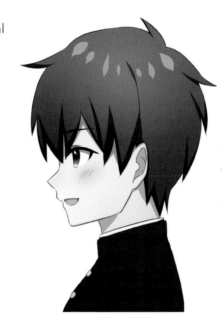

In the front view, it's important to create a round look for the young face, but in the side view, the angularity of the features takes over.

OLDER TEEN—SIDE VIEW

A definite, stylish hairstyle

Slimmer eyes

Accentuate the point of the chin.

Soften the angle of the jaw.

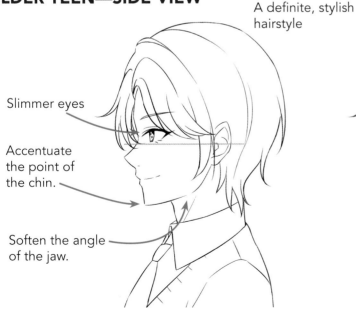

Often, beginners inadvertently flatten the back of the head. But the head is round in the back.

Full-Body Templates

You'll notice that guidelines are used when drawing the body just as they are when drawing the head. These basic body templates for high school girls and boys can be adjusted for almost any character you dream up.

GIRL'S BODY—FRONT VIEW

The most popular girl character is about 14-17 years of age. The shoulders are approximately as wide as the hips. Another important proportion to remember is that the upper body is long from the shoulders to the waist, but short from the waist to the bottom of the hips.

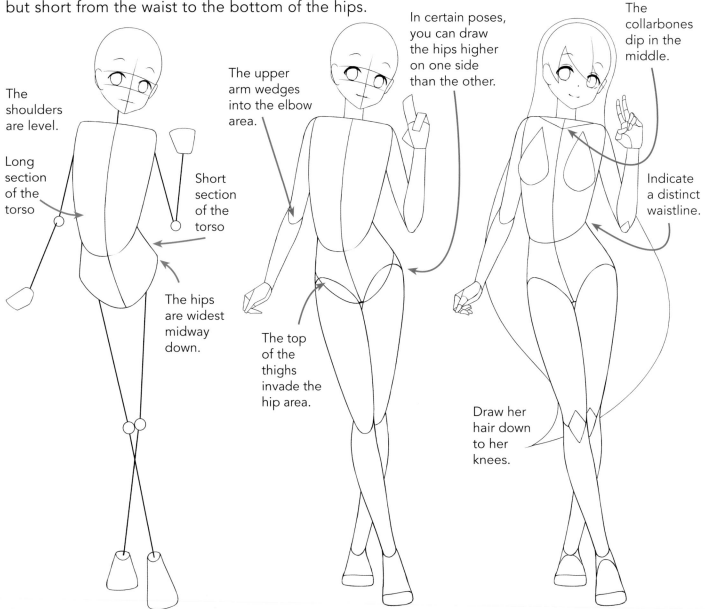

The shoulders are level.

Long section of the torso

Short section of the torso

The hips are widest midway down.

The upper arm wedges into the elbow area.

The top of the thighs invade the hip area.

In certain poses, you can draw the hips higher on one side than the other.

The collarbones dip in the middle.

Indicate a distinct waistline.

Draw her hair down to her knees.

Finishing Touches

Once you've taken your drawing as far as you can, it's time to finish up. This is what we call the editing process—where you decide what things to keep, what to adjust, and what to leave out.

Giving your character a brilliant hair color, like this gamma ray red, is an excellent way to capture the viewer's interest. It also suggests intense secondary colors, such as purple and black, to complement it.

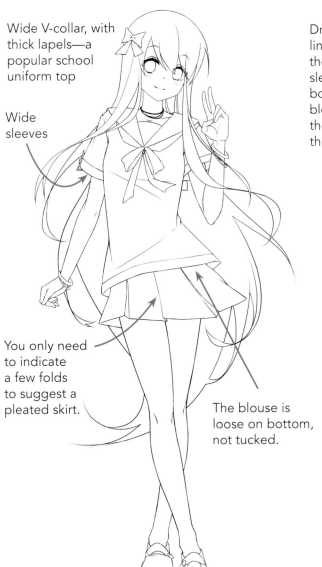

Wide V-collar, with thick lapels—a popular school uniform top

Wide sleeves

You only need to indicate a few folds to suggest a pleated skirt.

The blouse is loose on bottom, not tucked.

Draw thin trim lines around the collar, sleeves, the bottom of the blouse, and the bottom of the skirt.

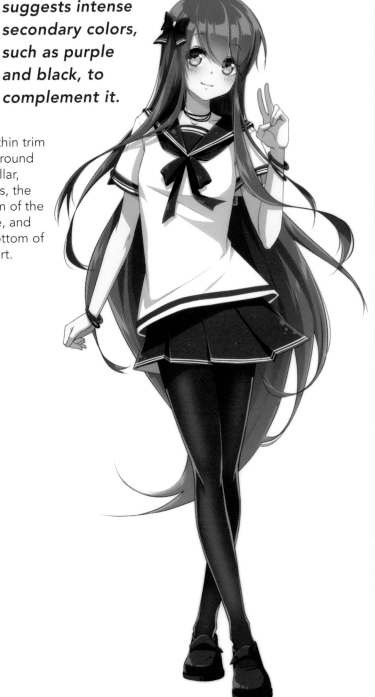

SIDE VIEW—GIRLS

When drawing the body in a side view, be careful not to allow it to flatten out in back. The human body is curvy in back but fairly straight in front. The curves are especially noticeable around the shoulder region and below the waist. The legs in the side view are also flatter in front and curvier in back.

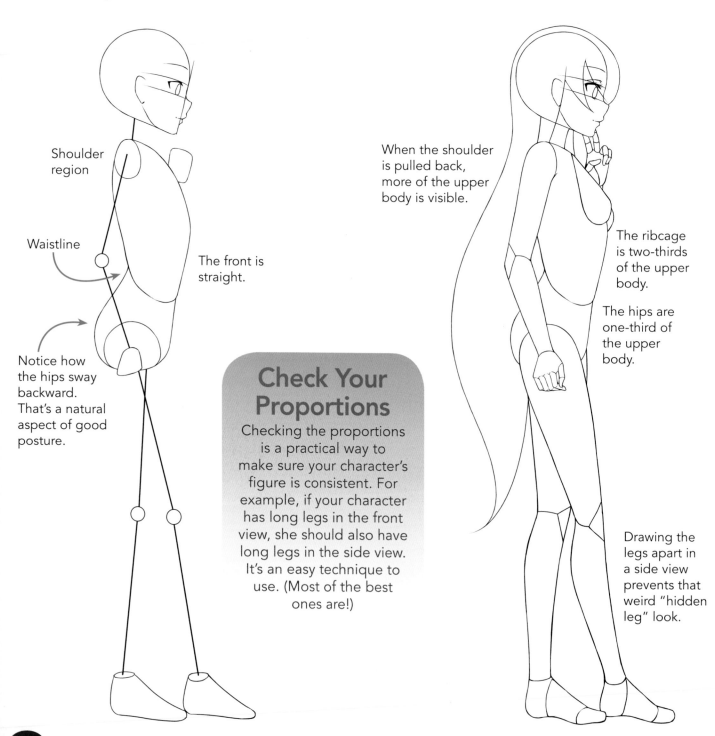

Shoulder region

Waistline

The front is straight.

Notice how the hips sway backward. That's a natural aspect of good posture.

When the shoulder is pulled back, more of the upper body is visible.

The ribcage is two-thirds of the upper body.

The hips are one-third of the upper body.

Drawing the legs apart in a side view prevents that weird "hidden leg" look.

Check Your Proportions

Checking the proportions is a practical way to make sure your character's figure is consistent. For example, if your character has long legs in the front view, she should also have long legs in the side view. It's an easy technique to use. (Most of the best ones are!)

To bring the style to another level, try gradating the hair. Gradating means changing one color gradually into another color, as shown where the red shifts to blue at the bottom.

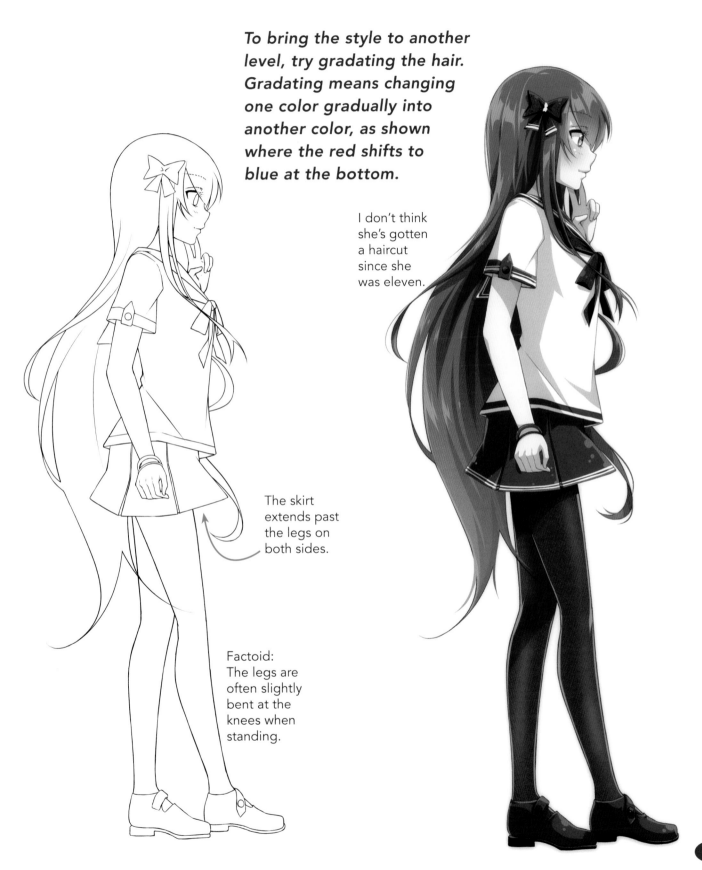

I don't think she's gotten a haircut since she was eleven.

The skirt extends past the legs on both sides.

Factoid: The legs are often slightly bent at the knees when standing.

BOY'S BODY—FRONT VIEW

One of the most popular boy character types is about 15 years old. He's trim with a medium build and of average height, but he's not the upperclassman, who is tall, lanky, and more stylized. (We'll see examples of that type later in this book.) The upper body of a male character is less flexible than a female's. There's not as much sway between ribcage and hips, therefore, you see a straighter posture. Part of this is due to proportions, since the shoulders are somewhat wider than those usually seen on girl characters.

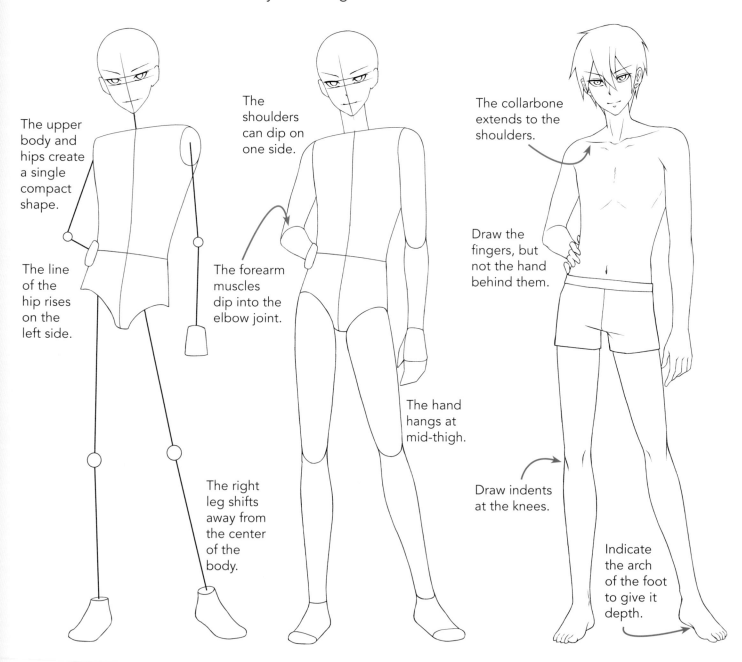

The upper body and hips create a single compact shape.

The line of the hip rises on the left side.

The right leg shifts away from the center of the body.

The shoulders can dip on one side.

The forearm muscles dip into the elbow joint.

The hand hangs at mid-thigh.

The collarbone extends to the shoulders.

Draw the fingers, but not the hand behind them.

Draw indents at the knees.

Indicate the arch of the foot to give it depth.

Creating Contrast with Color

If you like the high contrast look of manga—drawings in black and white—but you enjoy the color of anime, you can have the best of both worlds by substituting dark colors for black. But you have to know which colors to use. Lighter colors don't look good when darkened, as is the case with a muddy yellow. But colors like a dark red or a dark purple are excellent substitutes for black. This character's dark purple hair and vest are more eye-catching than a black and white version would be.

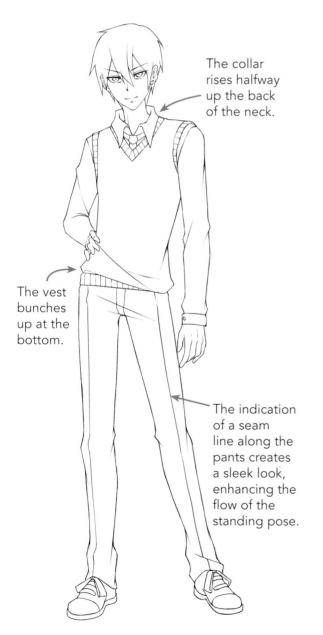

The collar rises halfway up the back of the neck.

The vest bunches up at the bottom.

The indication of a seam line along the pants creates a sleek look, enhancing the flow of the standing pose.

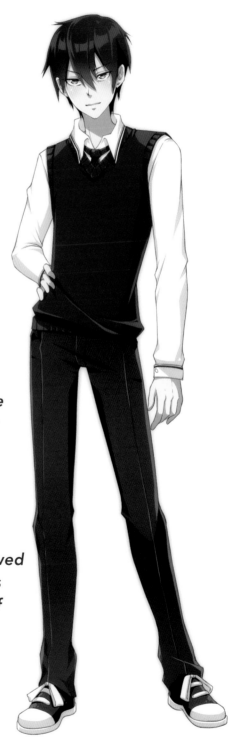

The teen boy can wear a traditional school uniform, like a jacket and tie, or something simpler and sportier, like a sweater vest, long sleeve shirt, and slacks. Are those athletic shoes allowed by the school dress code? I won't tell if you won't.

SIDE VIEW—BOYS

High school boys have thin builds, but they still have contours. You can avoid drawing a stiff looking figure if you try to use curved lines wherever possible. His lower back is not as indented, generally, as a female's lower back, but it still curves inward. On the front, the chest is rounded and juts outward. His neck is set back from the chest.

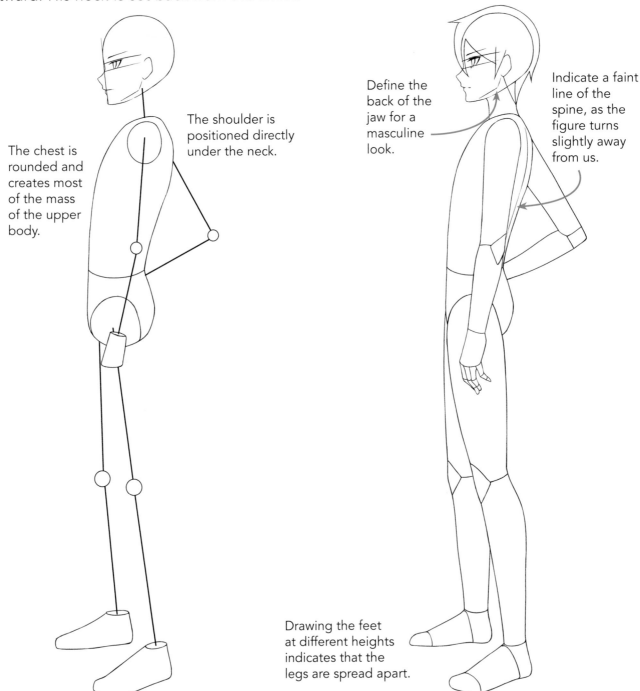

The chest is rounded and creates most of the mass of the upper body.

The shoulder is positioned directly under the neck.

Define the back of the jaw for a masculine look.

Indicate a faint line of the spine, as the figure turns slightly away from us.

Drawing the feet at different heights indicates that the legs are spread apart.

Imperfections make things appear lifelike. A minor bend at the knee and a few creases of clothing is all it takes.

The collar extends forward, past the neck and onto the chest.

The sweater drops below the belt line.

Because the front leg is turned slightly toward us, we can see the seam line.

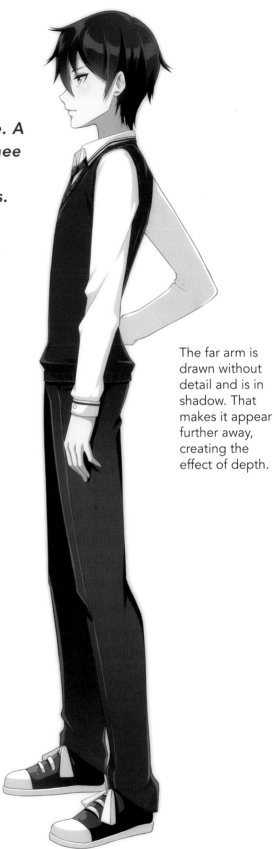

The far arm is drawn without detail and is in shadow. That makes it appear further away, creating the effect of depth.

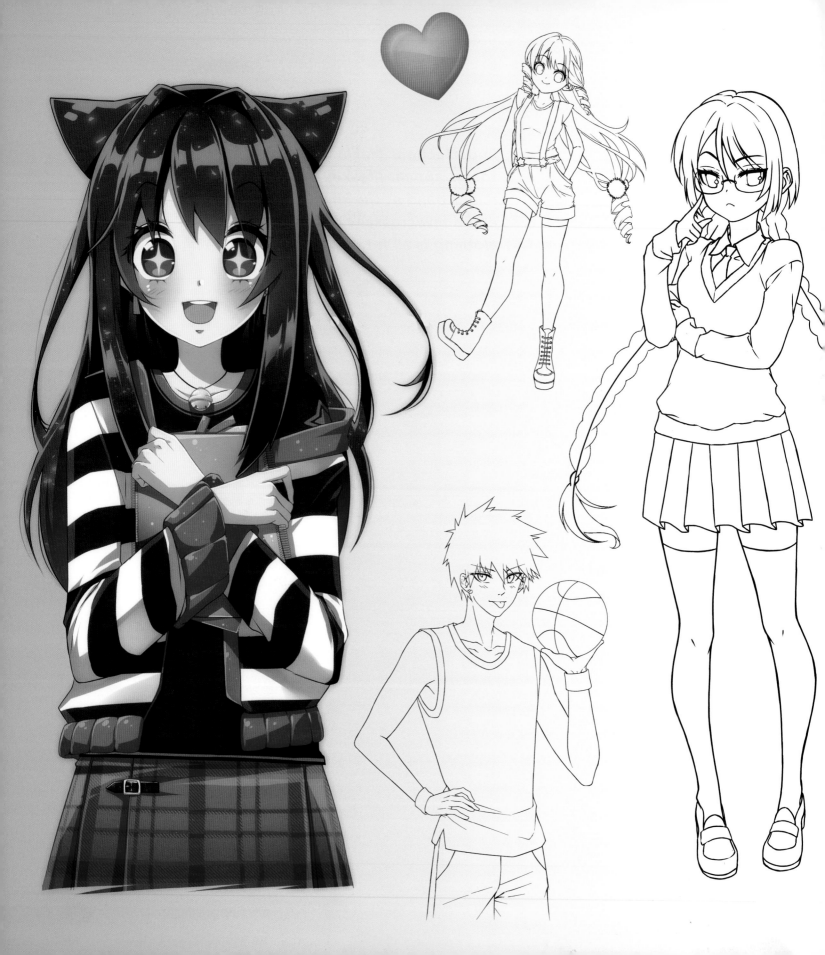

Popular Romance Character Types

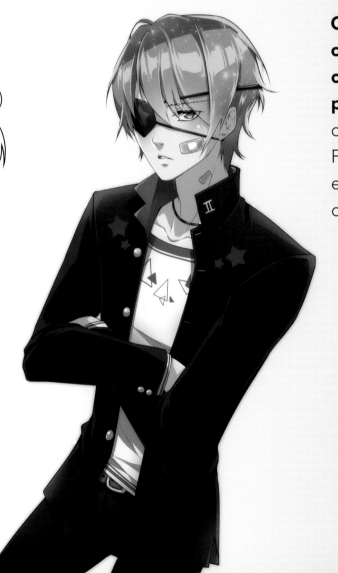

Character design is fun! It's a process of invention that allows an artist to create a unique individual based on a personality trait. To invent a dynamic character, focus on one overriding concept. For example, emphasize the eyes, hair, expression, or outfit. These aspects of a character help to define who they are.

Big Crush

Because the eyes are the focus of the face, we use them to create expressive characters. One way to do this is to draw the shines of the eyes as an icon. In this example, the eye shines of a character with a crush can be drawn as starbursts. This means she's not just happy to see you, she's head over heels in love!

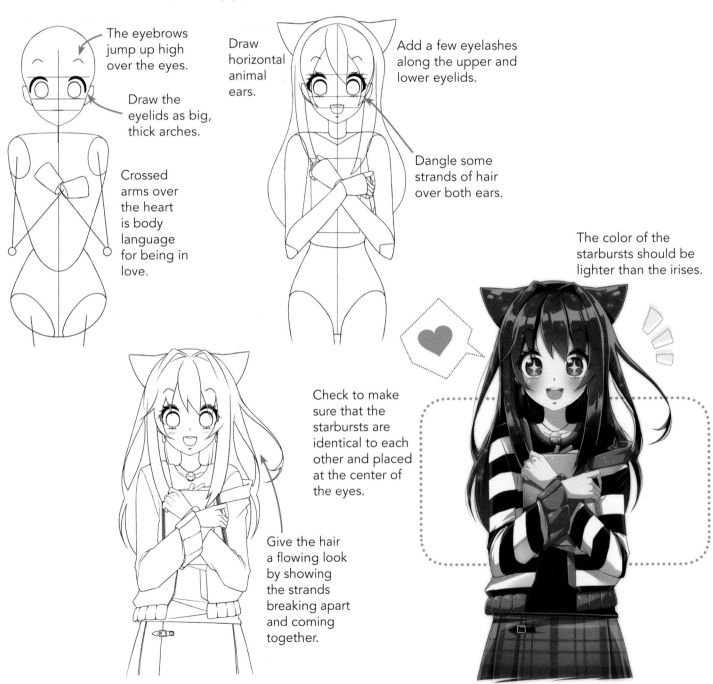

The eyebrows jump up high over the eyes.

Draw the eyelids as big, thick arches.

Crossed arms over the heart is body language for being in love.

Draw horizontal animal ears.

Add a few eyelashes along the upper and lower eyelids.

Dangle some strands of hair over both ears.

The color of the starbursts should be lighter than the irises.

Check to make sure that the starbursts are identical to each other and placed at the center of the eyes.

Give the hair a flowing look by showing the strands breaking apart and coming together.

On the Go

This type has made lots of social plans—all happening at the same time! Just as some characters are created with an emphasis on the eyes, others are based on concealing this prominent feature. This makes her look a little scattered.

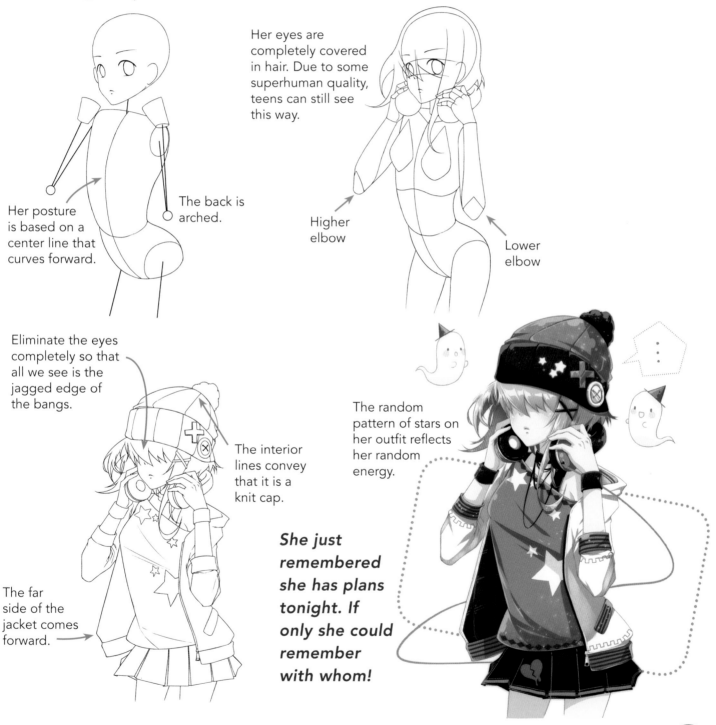

Her posture is based on a center line that curves forward.

The back is arched.

Her eyes are completely covered in hair. Due to some superhuman quality, teens can still see this way.

Higher elbow

Lower elbow

Eliminate the eyes completely so that all we see is the jagged edge of the bangs.

The interior lines convey that it is a knit cap.

The far side of the jacket comes forward.

The random pattern of stars on her outfit reflects her random energy.

She just remembered she has plans tonight. If only she could remember with whom!

Hair Overload

Her whole identity is wrapped up in a hairbrush and a blow dryer. Crazy hair is entertaining. It swirls and changes direction, creating an endlessly flowing pattern. Flowing yellow ribbons are the perfect accessory.

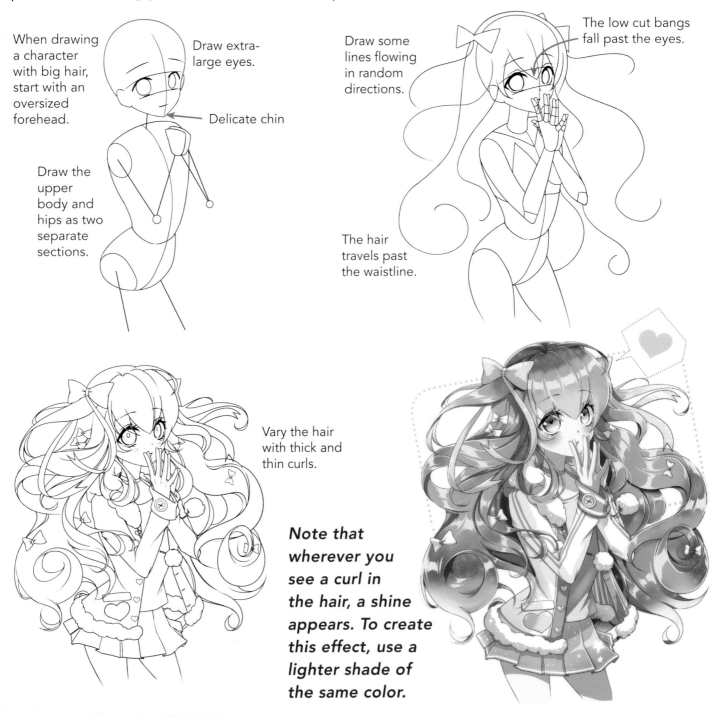

When drawing a character with big hair, start with an oversized forehead.

Draw extra-large eyes.

Delicate chin

Draw the upper body and hips as two separate sections.

Draw some lines flowing in random directions.

The low cut bangs fall past the eyes.

The hair travels past the waistline.

Vary the hair with thick and thin curls.

Note that wherever you see a curl in the hair, a shine appears. To create this effect, use a lighter shade of the same color.

The Star Player

Much of this character's identity is wrapped up in which sport he plays and what team he's on. Generally speaking, the better he is with his jump shot, the more popular he'll be as a character type.

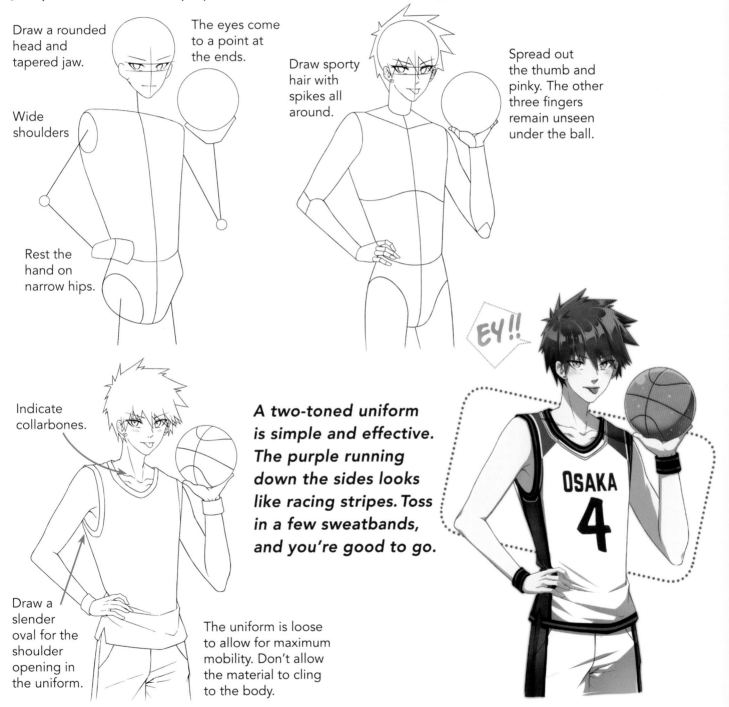

Draw a rounded head and tapered jaw.

The eyes come to a point at the ends.

Wide shoulders

Rest the hand on narrow hips.

Draw sporty hair with spikes all around.

Spread out the thumb and pinky. The other three fingers remain unseen under the ball.

Indicate collarbones.

Draw a slender oval for the shoulder opening in the uniform.

The uniform is loose to allow for maximum mobility. Don't allow the material to cling to the body.

A two-toned uniform is simple and effective. The purple running down the sides looks like racing stripes. Toss in a few sweatbands, and you're good to go.

EY!!

OSAKA
4

The Outsider

He's not exactly what a girl's parents had in mind, but you can't judge a book by its cover. Draw him in a slightly defiant stance with his arms folded in front of him.

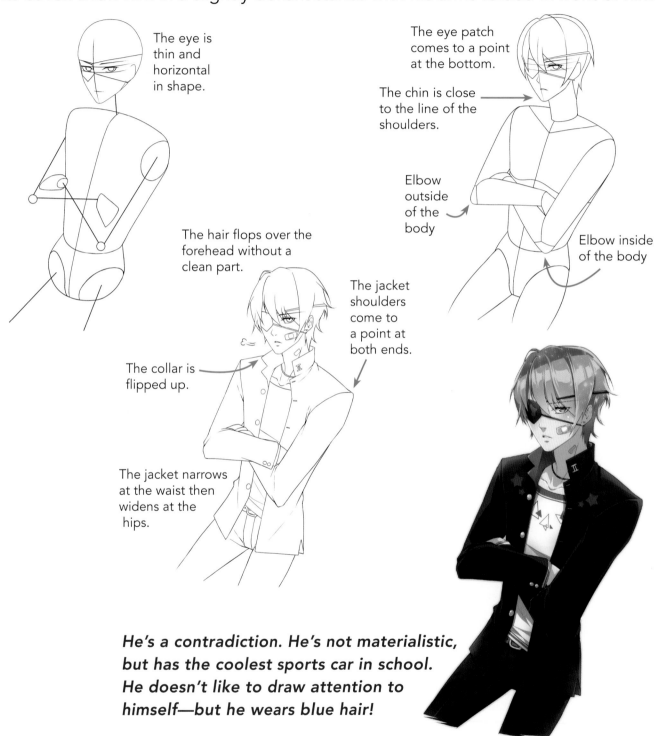

The eye is thin and horizontal in shape.

The eye patch comes to a point at the bottom.

The chin is close to the line of the shoulders.

Elbow outside of the body

Elbow inside of the body

The hair flops over the forehead without a clean part.

The jacket shoulders come to a point at both ends.

The collar is flipped up.

The jacket narrows at the waist then widens at the hips.

He's a contradiction. He's not materialistic, but has the coolest sports car in school. He doesn't like to draw attention to himself—but he wears blue hair!

Anime Pop

I wouldn't recommend wearing this outfit to school, but it's a good look at anime conventions.

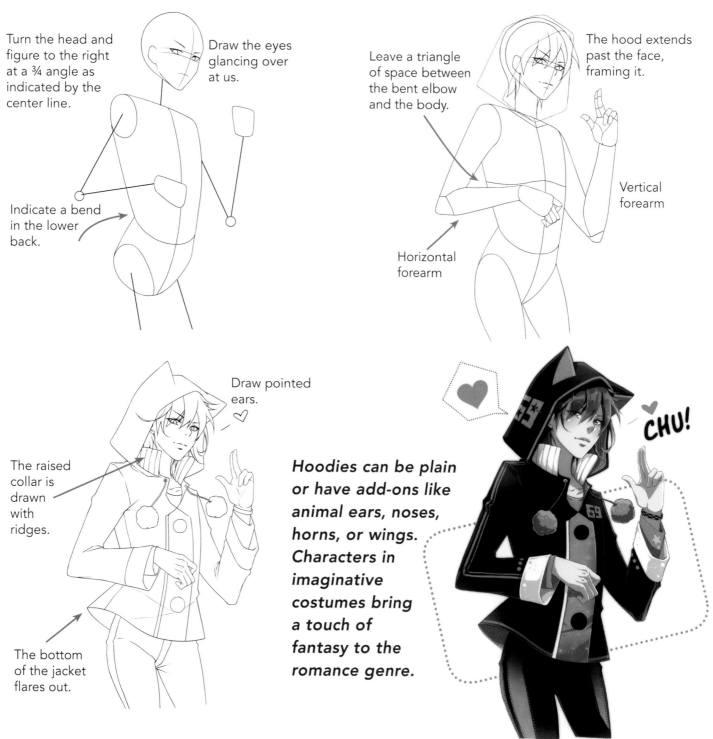

Turn the head and figure to the right at a ¾ angle as indicated by the center line.

Draw the eyes glancing over at us.

Indicate a bend in the lower back.

Leave a triangle of space between the bent elbow and the body.

The hood extends past the face, framing it.

Vertical forearm

Horizontal forearm

Draw pointed ears.

The raised collar is drawn with ridges.

The bottom of the jacket flares out.

Hoodies can be plain or have add-ons like animal ears, noses, horns, or wings. Characters in imaginative costumes bring a touch of fantasy to the romance genre.

CHU!

Emotionally Vulnerable

Anime features many sweet and charming characters. These gentle types nicely counterbalance the high-energy personalities. This temperament works well with steep bangs and long, relaxed hair that flows down the back. It also helps to use an expressive pose.

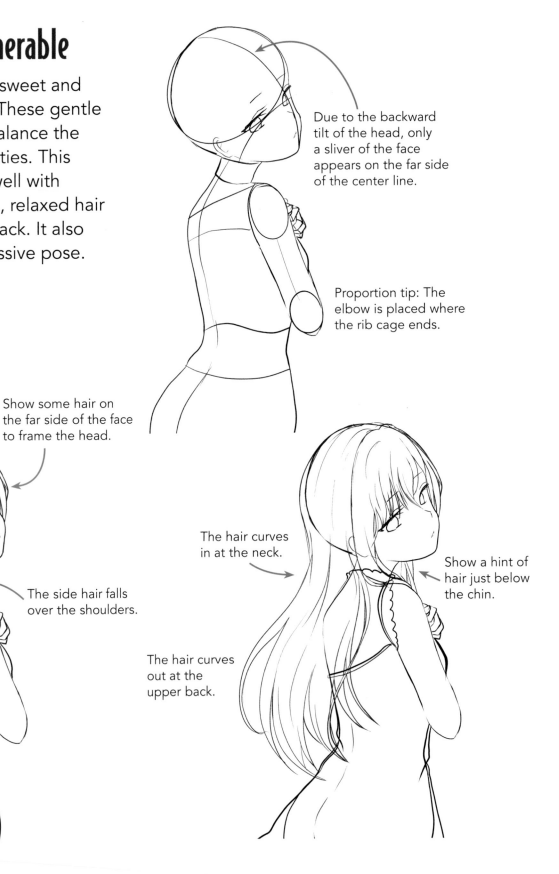

Due to the backward tilt of the head, only a sliver of the face appears on the far side of the center line.

Proportion tip: The elbow is placed where the rib cage ends.

Show some hair on the far side of the face to frame the head.

The side hair falls over the shoulders.

The hair curves in at the neck.

Show a hint of hair just below the chin.

The hair curves out at the upper back.

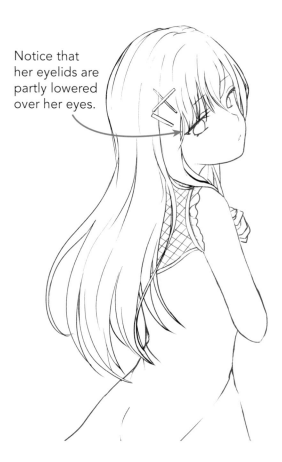

Notice that her eyelids are partly lowered over her eyes.

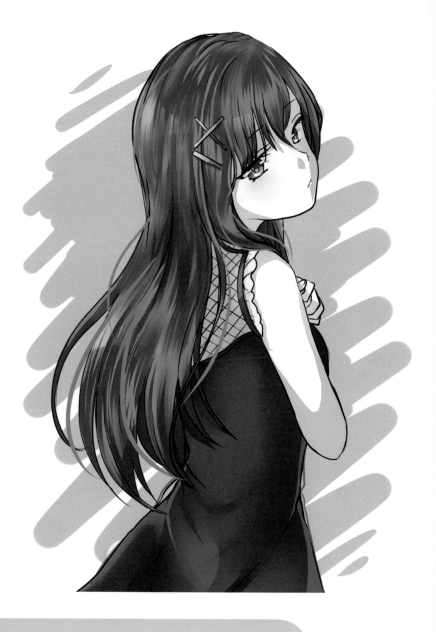

Hairstyle Tips

Here are a few techniques for drawing hair that you can add to your skill set:

- To make the hair look full, draw the bangs down to the eyes.

- When choosing a hair color, include some lighter and darker shades within a single style.

- Use accessories to add interest to a hair style. Barrettes, bows, headbands, and even cat ears can be used to help communicate the character's personality.

Idol

Idols are performers, usually singers or dancers, who entertain hundreds, and even thousands, of fans on stage. Usually, everything goes well, but once in a while a fan can get obsessed.

Draw a round head, facing forward. This will create a symmetrical basis for the hairdo.

Draw heavy eyelashes.

Performers usually have energetic poses.

Her truncated torso indicates a young character.

The pigtails start off fat, then narrow at the ends, where they get squiggly.

Draw some decorations for the outfit to add more glamour, such as heart-shaped bows, musical notes, cute monsters, or anything else you come up with.

Her fingers loosely grip the microphone.

Idol characters frequently employ strong color themes to create a magical aura around the character. This is important because they have to create a big presence on stage. The fantasy theme for this character revolves around green, pink, and purple.

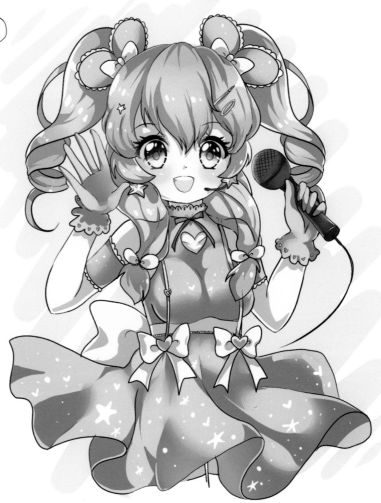

Heiress

It's never difficult to tell which character is the wealthy one. Count on her to make a show of it. Her clothes are extravagant, and her hairstyle requires a three-day weekend to complete. You can't insult her by calling her spoiled. She'll take it as a compliment.

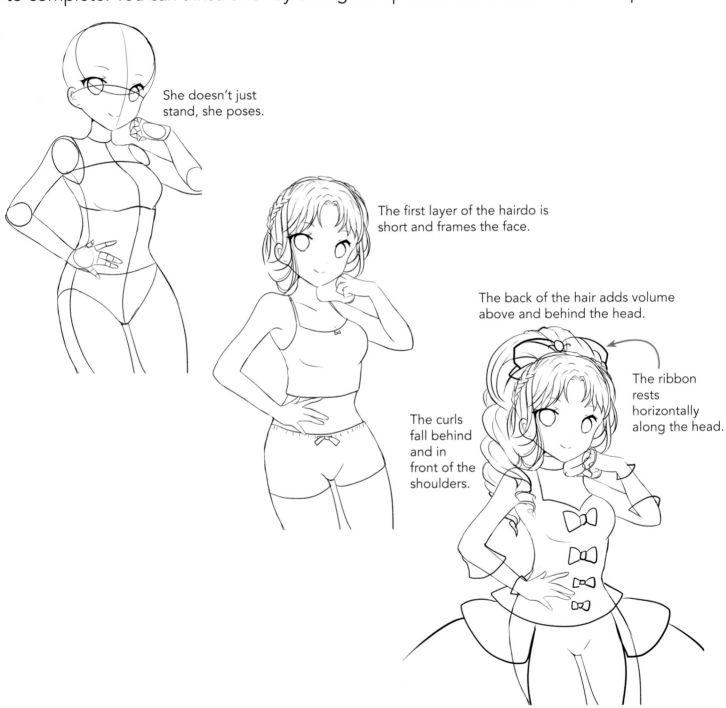

She doesn't just stand, she poses.

The first layer of the hairdo is short and frames the face.

The back of the hair adds volume above and behind the head.

The ribbon rests horizontally along the head.

The curls fall behind and in front of the shoulders.

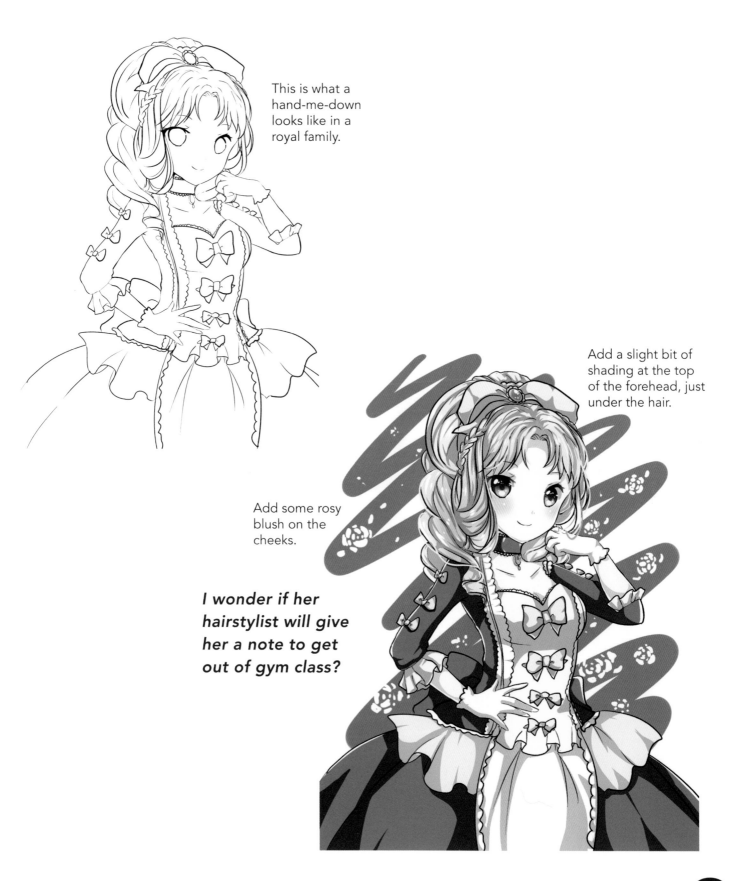

This is what a hand-me-down looks like in a royal family.

Add a slight bit of shading at the top of the forehead, just under the hair.

Add some rosy blush on the cheeks.

I wonder if her hairstylist will give her a note to get out of gym class?

Attitudes and Stances

Romance characters come with a surplus of attitudes. Someone shows interest in your boyfriend? Attitude. That person steals your boyfriend? Bigger attitude. Drawing attitudes for your characters is such an effective way of communicating ideas, you can often use them instead of words. Let's give it a try.

Distrustful

She demands that he account for his whereabouts every time he leaves her sight. Did he really go to the locker to get his books? Did he speak to anyone while he was there? No, but he thought about it!

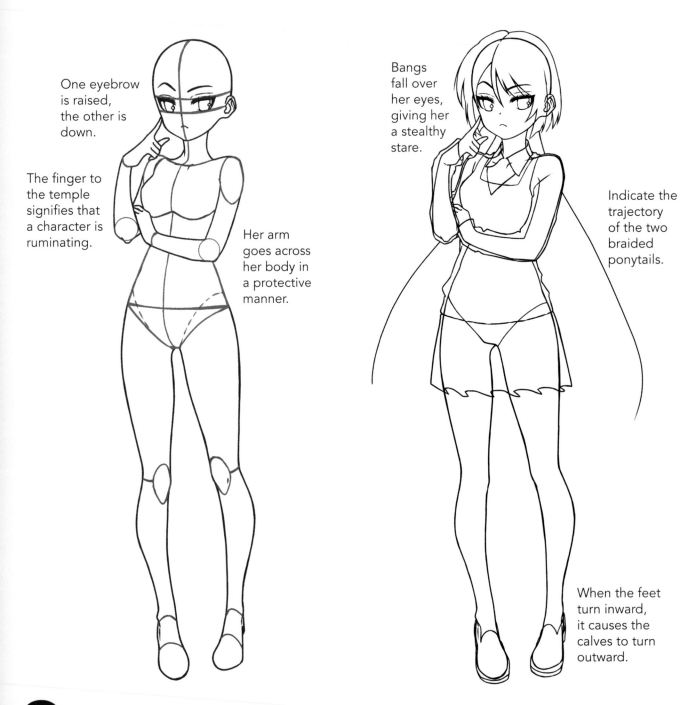

One eyebrow is raised, the other is down.

The finger to the temple signifies that a character is ruminating.

Her arm goes across her body in a protective manner.

Bangs fall over her eyes, giving her a stealthy stare.

Indicate the trajectory of the two braided ponytails.

When the feet turn inward, it causes the calves to turn outward.

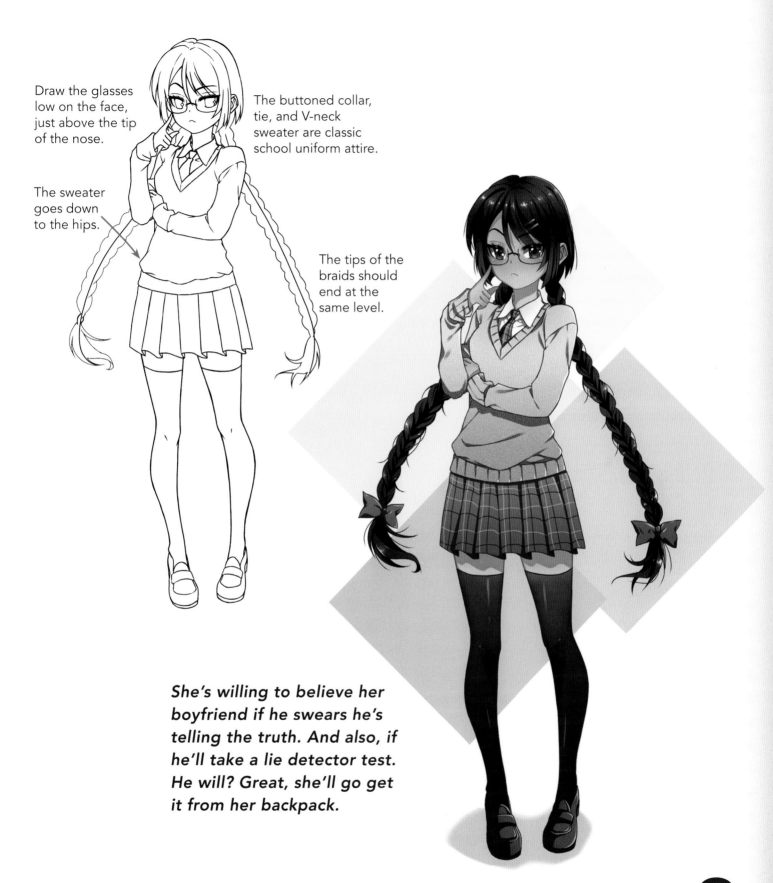

Draw the glasses low on the face, just above the tip of the nose.

The buttoned collar, tie, and V-neck sweater are classic school uniform attire.

The sweater goes down to the hips.

The tips of the braids should end at the same level.

She's willing to believe her boyfriend if he swears he's telling the truth. And also, if he'll take a lie detector test. He will? Great, she'll go get it from her backpack.

Upbeat

There's a bounce in her step since her crush texted her back. But if he doesn't text again within five minutes, she'll be down in the dumps again!

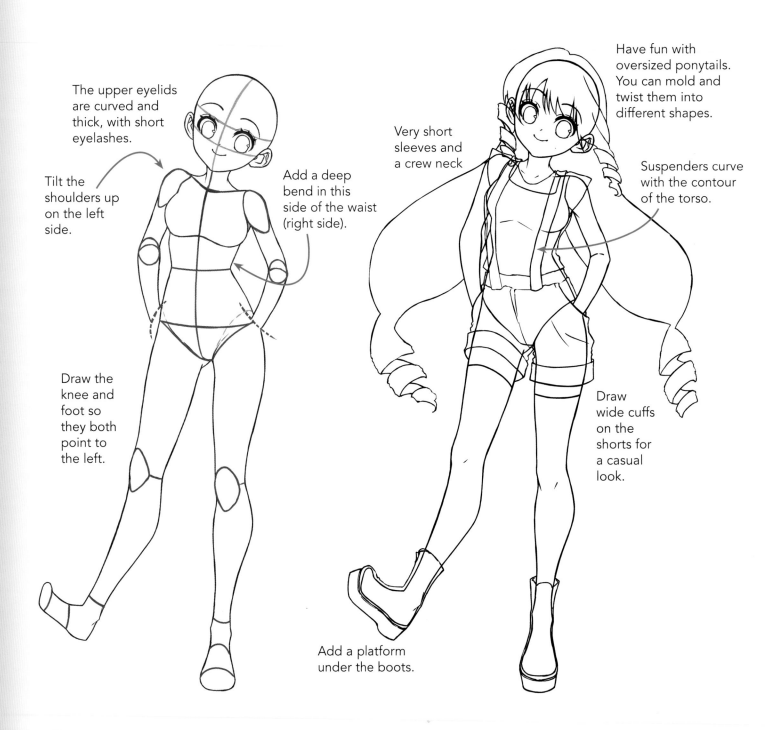

The upper eyelids are curved and thick, with short eyelashes.

Tilt the shoulders up on the left side.

Add a deep bend in this side of the waist (right side).

Draw the knee and foot so they both point to the left.

Have fun with oversized ponytails. You can mold and twist them into different shapes.

Very short sleeves and a crew neck

Suspenders curve with the contour of the torso.

Draw wide cuffs on the shorts for a casual look.

Add a platform under the boots.

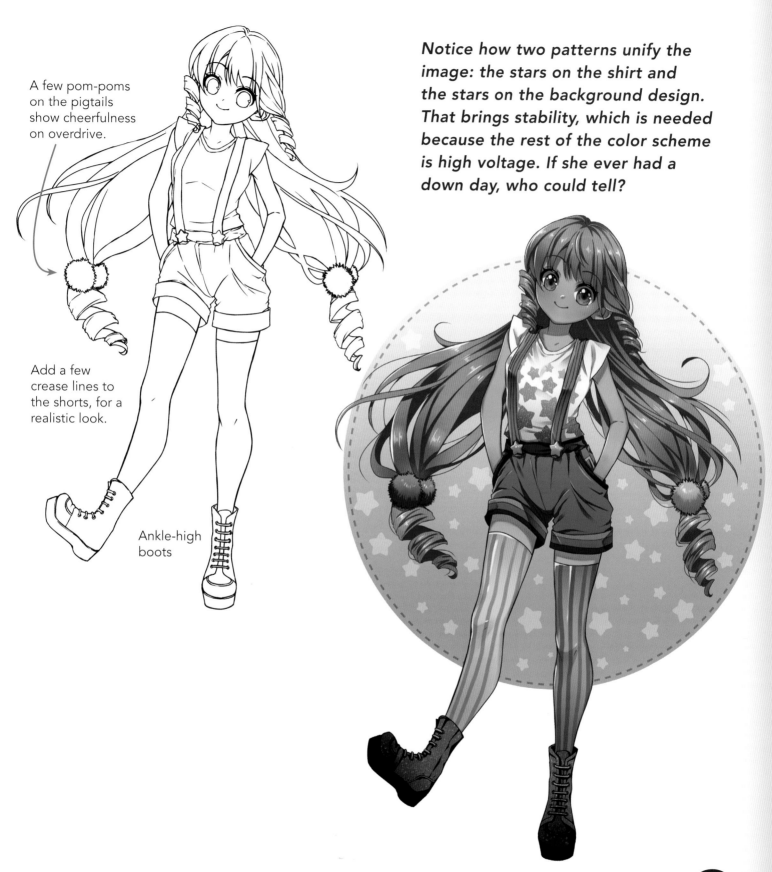

A few pom-poms on the pigtails show cheerfulness on overdrive.

Add a few crease lines to the shorts, for a realistic look.

Ankle-high boots

Notice how two patterns unify the image: the stars on the shirt and the stars on the background design. That brings stability, which is needed because the rest of the color scheme is high voltage. If she ever had a down day, who could tell?

Infatuation

She's only known him for two seconds and she's already planning to send out wedding invitations. It's natural for anime characters to fall head over heels. The infatuation stage lasts a couple weeks, followed by the "discovery of his faults" stage, followed closely by the "I will improve you" stage, followed inevitably by the "I'm outta here" stage.

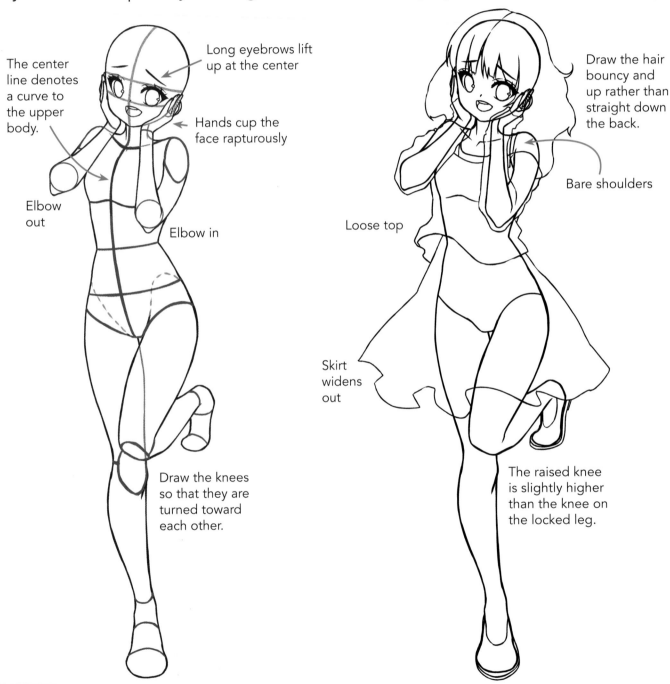

The center line denotes a curve to the upper body.

Long eyebrows lift up at the center

Hands cup the face rapturously

Elbow out

Elbow in

Draw the knees so that they are turned toward each other.

Draw the hair bouncy and up rather than straight down the back.

Bare shoulders

Loose top

Skirt widens out

The raised knee is slightly higher than the knee on the locked leg.

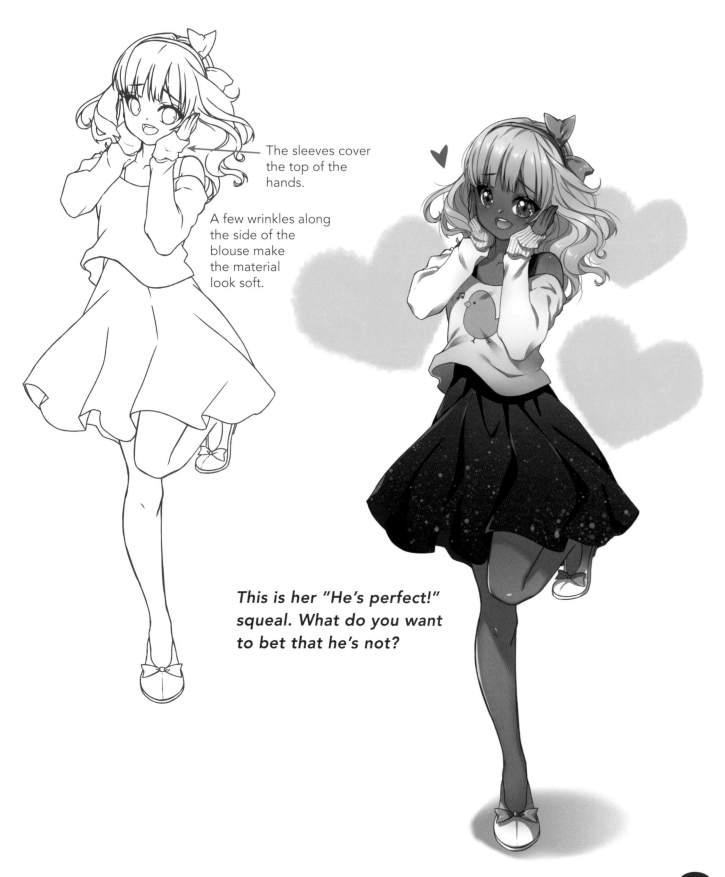

The sleeves cover the top of the hands.

A few wrinkles along the side of the blouse make the material look soft.

This is her "He's perfect!" squeal. What do you want to bet that he's not?

Lonely Girl

Many popular stories start with the premise that one's true love is moving far away. Maybe the boy's parents got a new job. With any luck, her boyfriend's parents will get fired from their jobs and have to move back here. Wow, that's cold, but honest. Or maybe the popular guy at her school will be dumped by his true love and finally notice her. Wow, pretty honest again.

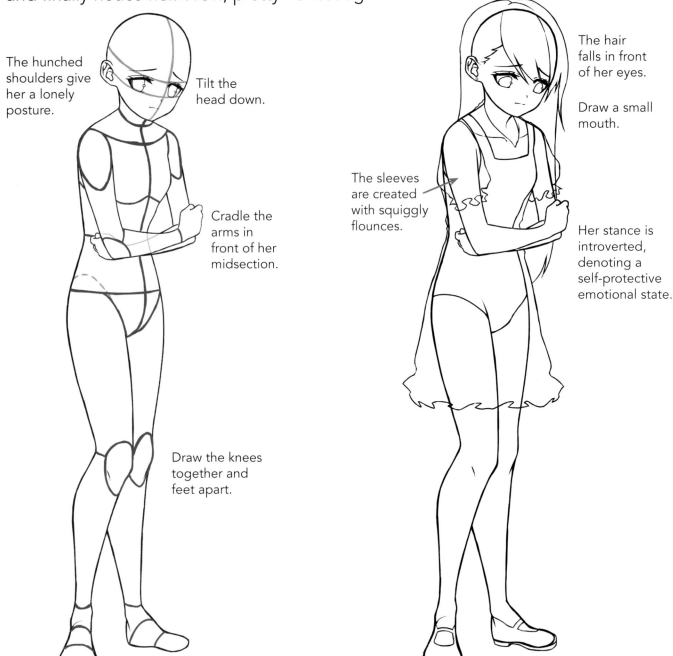

The hunched shoulders give her a lonely posture.

Tilt the head down.

Cradle the arms in front of her midsection.

Draw the knees together and feet apart.

The hair falls in front of her eyes.

Draw a small mouth.

The sleeves are created with squiggly flounces.

Her stance is introverted, denoting a self-protective emotional state.

A traditional pink dress indicates a proper character who is kinda shy. She doesn't realize that another boy at school likes her—but he's shy, too. That means that Halley's comet will pass by earth before either of them will say hi to the other.

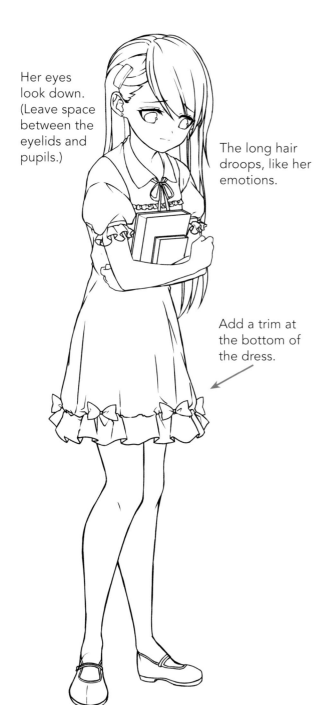

Her eyes look down. (Leave space between the eyelids and pupils.)

The long hair droops, like her emotions.

Add a trim at the bottom of the dress.

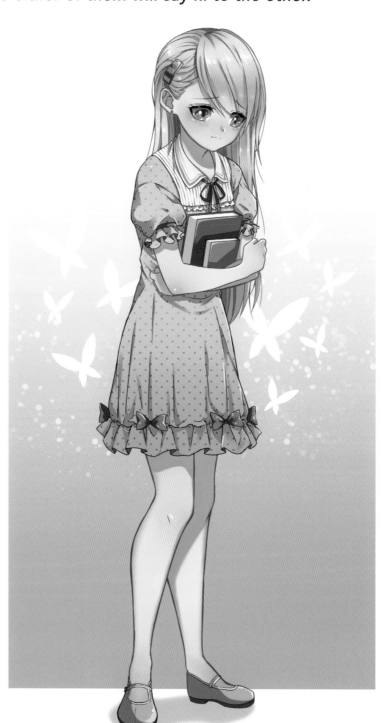

Super-Defensive

Super-defensive characters are fun because they are always looking for hidden meanings. If you said, "You look nice today," to a super-defensive person, she would probably respond by saying, "What do you mean by *today*? Are you saying you hated how I looked yesterday?"

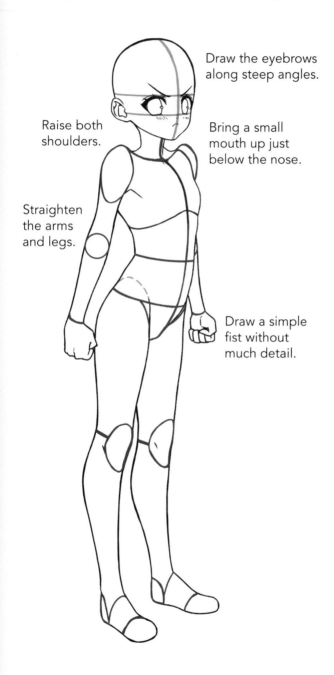

Draw the eyebrows along steep angles.

Raise both shoulders.

Bring a small mouth up just below the nose.

Straighten the arms and legs.

Draw a simple fist without much detail.

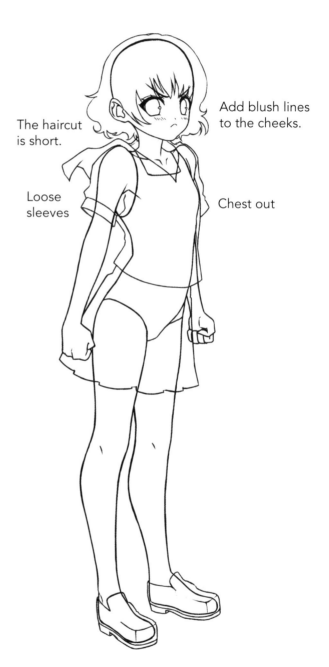

The haircut is short.

Add blush lines to the cheeks.

Loose sleeves

Chest out

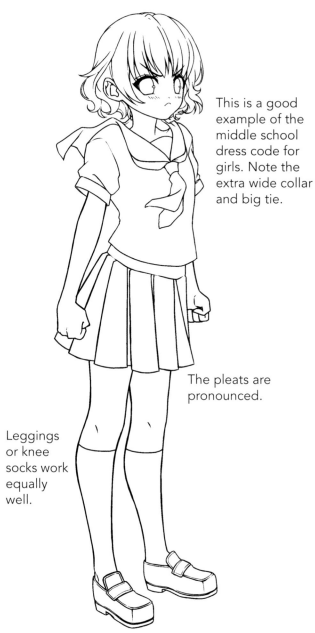

This is a good example of the middle school dress code for girls. Note the extra wide collar and big tie.

The pleats are pronounced.

Leggings or knee socks work equally well.

You can indicate sound effects without actually using letters or words. These sound effects read as dissonance or a jumble of emotions. You'll also notice that her hair is a hot color—pink—rather than a calming color like brown. The collar and tie appear to flap, as if they were as upset as she is!

Obsessed

The obsessed character type loves everything about her favorite pop star. How he looks, what he wears, the day of the week when he was born, and his favorite color. (Purple. She read it in an interview). Her parents are concerned for her. His parents are concerned for him!

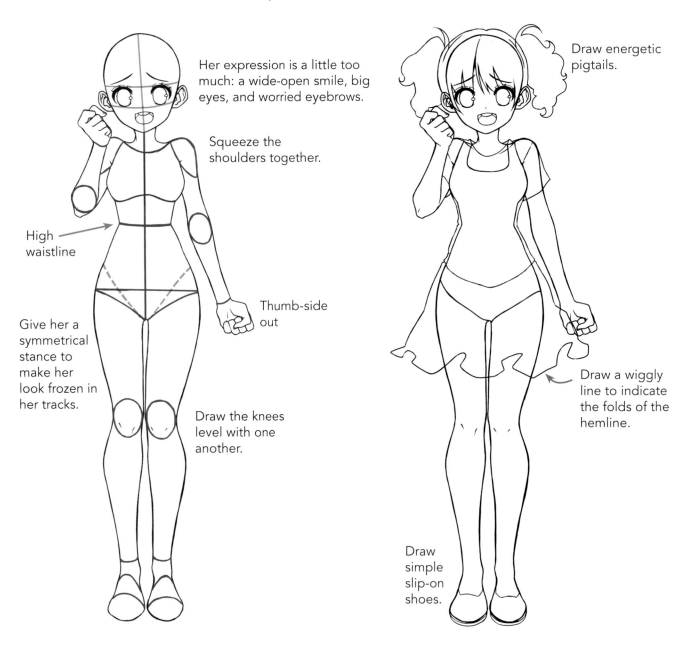

Her expression is a little too much: a wide-open smile, big eyes, and worried eyebrows.

Squeeze the shoulders together.

High waistline

Thumb-side out

Give her a symmetrical stance to make her look frozen in her tracks.

Draw the knees level with one another.

Draw energetic pigtails.

Draw a wiggly line to indicate the folds of the hemline.

Draw simple slip-on shoes.

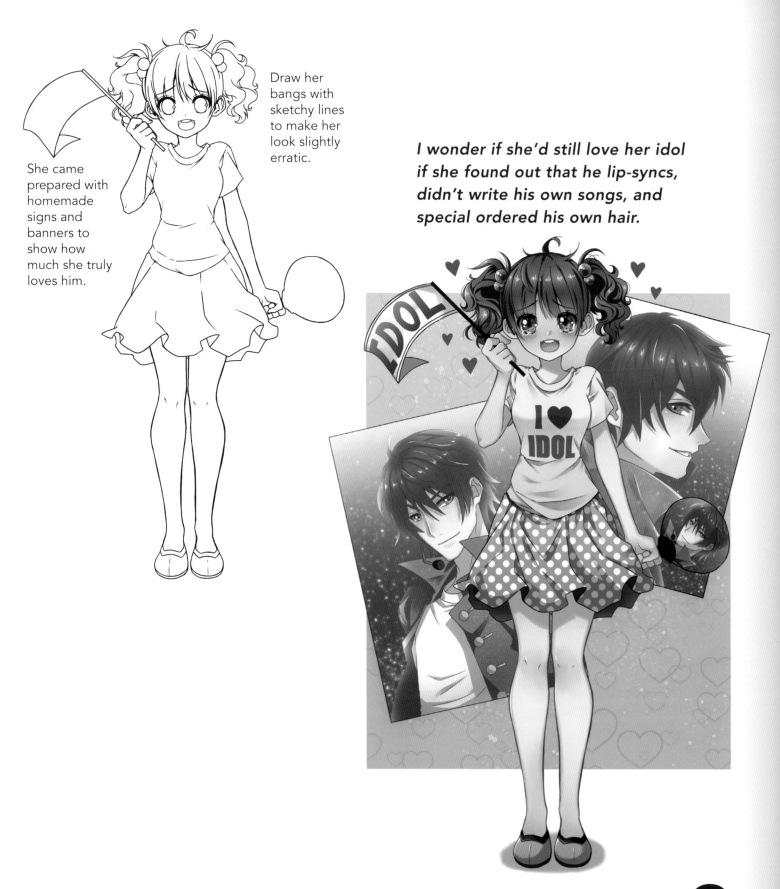

Draw her bangs with sketchy lines to make her look slightly erratic.

She came prepared with homemade signs and banners to show how much she truly loves him.

I wonder if she'd still love her idol if she found out that he lip-syncs, didn't write his own songs, and special ordered his own hair.

55

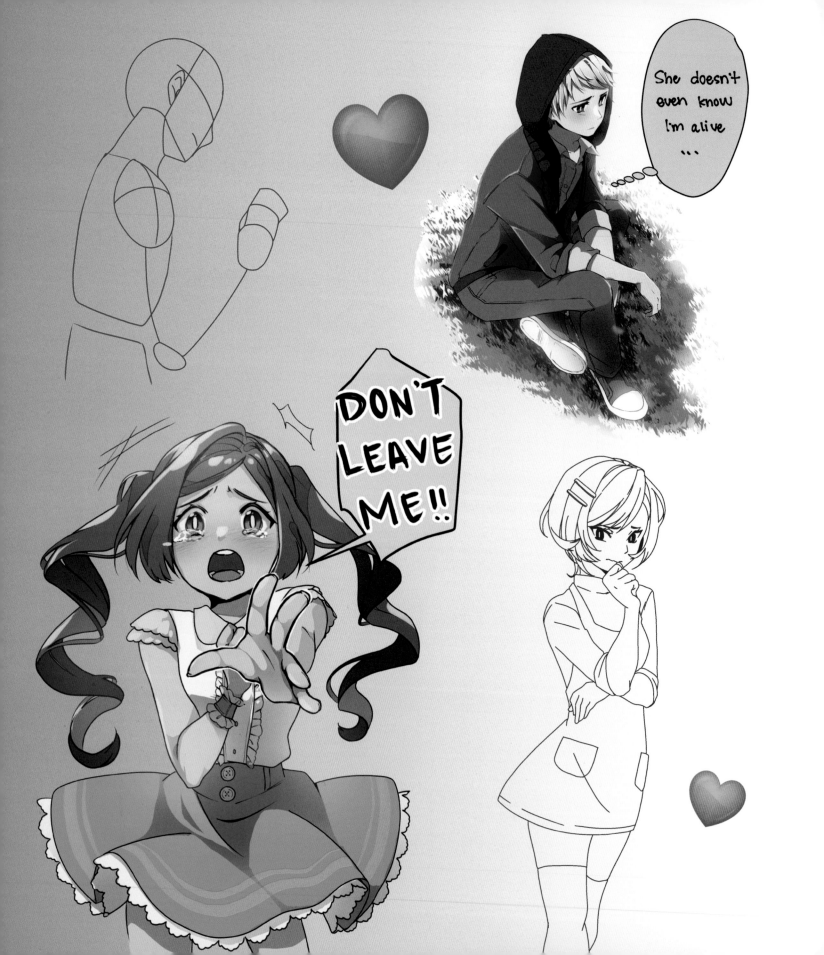

Key Story Points

Audiences like to watch characters wrestle with their feelings because it adds to the drama. A character at a turning point in the story raises the emotional temperature of the scene. For example, it wouldn't raise the intensity if a boy said to a girl, "Goodbye." But it would if he said, "Goodbye forever!" Turning points make for good drama. Let's find out how to create them.

HE BROKE UP WITH ME WITH A **TEXT** !??

A Love that Can Never Be

The guy she likes hasn't asked her to the prom. But don't worry. The boy next door, the boring one her parents approve of, will ask her. Bwaaaaaa!!!

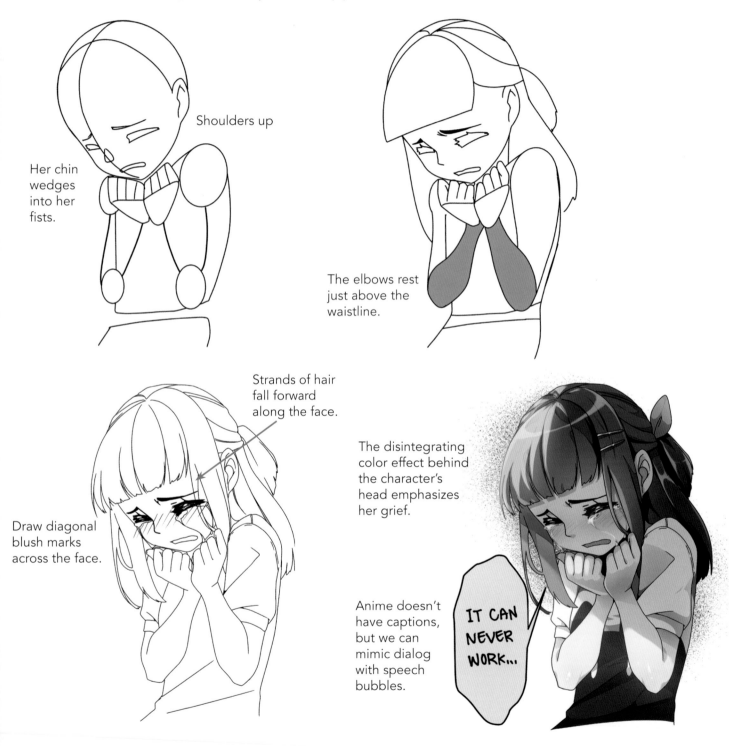

Shoulders up

Her chin wedges into her fists.

The elbows rest just above the waistline.

Strands of hair fall forward along the face.

Draw diagonal blush marks across the face.

The disintegrating color effect behind the character's head emphasizes her grief.

Anime doesn't have captions, but we can mimic dialog with speech bubbles.

IT CAN NEVER WORK...

A One-Sided Crush

Much of the drama in romance comes from one person liking the other too much. This causes the other person to try to break free from the situation—which causes the first person to hold on even tighter. You can emphasize this conflict by drawing her hand stretched out in perspective.

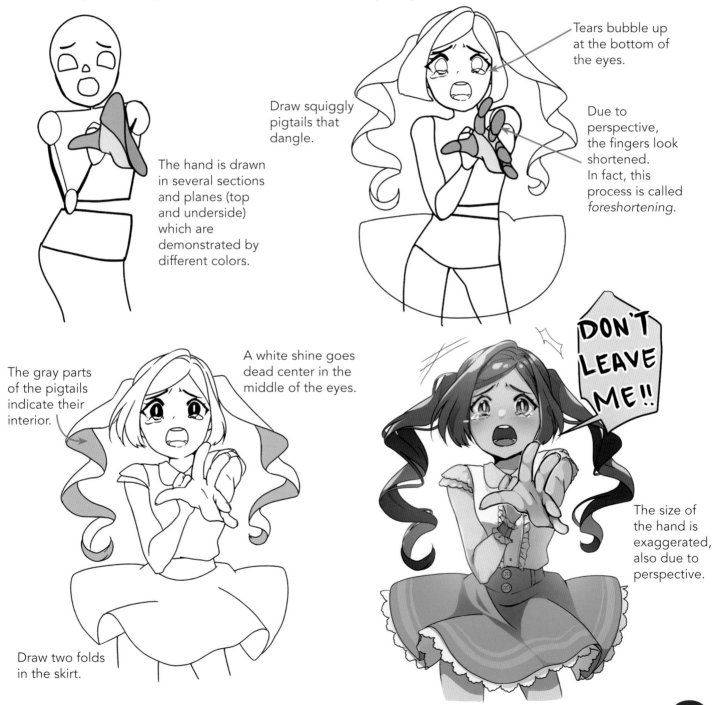

Draw squiggly pigtails that dangle.

The hand is drawn in several sections and planes (top and underside) which are demonstrated by different colors.

Tears bubble up at the bottom of the eyes.

Due to perspective, the fingers look shortened. In fact, this process is called *foreshortening*.

The gray parts of the pigtails indicate their interior.

A white shine goes dead center in the middle of the eyes.

Draw two folds in the skirt.

DON'T LEAVE ME!!

The size of the hand is exaggerated, also due to perspective.

The Epic Cry of Love

When drawing a character who is misunderstood, you don't have to be specific about what is troubling him. Why not? Because that would make him understood! Leave his rage undefined. Maybe his girlfriend isn't returning his calls. Maybe her ex-boyfriend is back in the picture. Or worst of all, maybe his parents are pressuring him to get a job.

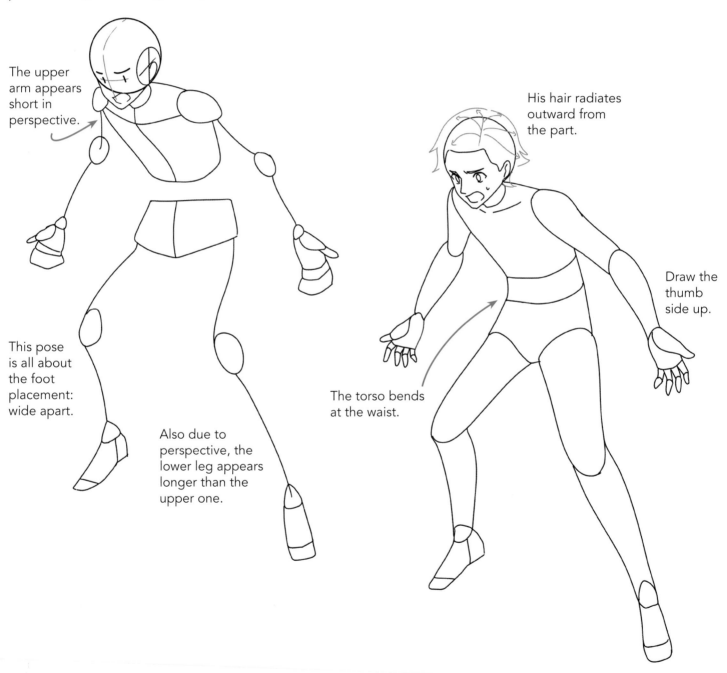

The upper arm appears short in perspective.

This pose is all about the foot placement: wide apart.

Also due to perspective, the lower leg appears longer than the upper one.

His hair radiates outward from the part.

Draw the thumb side up.

The torso bends at the waist.

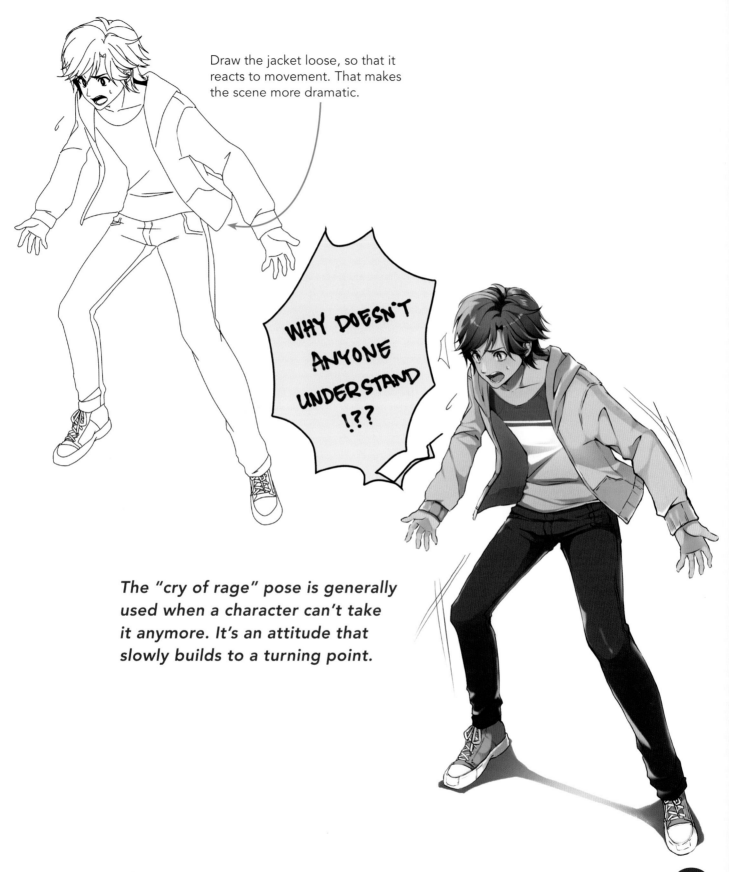

Draw the jacket loose, so that it reacts to movement. That makes the scene more dramatic.

WHY DOESN'T ANYONE UNDERSTAND !??

The "cry of rage" pose is generally used when a character can't take it anymore. It's an attitude that slowly builds to a turning point.

Possessive

She's always checking her boyfriend's phone and catching him in the act of leaving messages—to her! But he's not out of the woods yet. Sometimes, her doubts turn out to be right. At first, she may try to ignore the signs. But when the evidence begins to mount, what started as a comedy may end up as a drama.

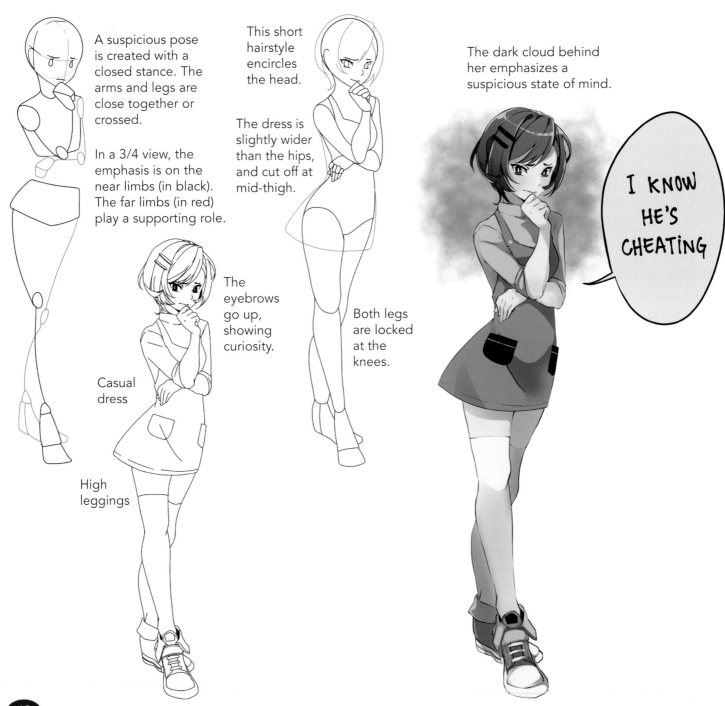

A suspicious pose is created with a closed stance. The arms and legs are close together or crossed.

In a 3/4 view, the emphasis is on the near limbs (in black). The far limbs (in red) play a supporting role.

This short hairstyle encircles the head.

The dress is slightly wider than the hips, and cut off at mid-thigh.

The eyebrows go up, showing curiosity.

Casual dress

High leggings

Both legs are locked at the knees.

The dark cloud behind her emphasizes a suspicious state of mind.

I KNOW HE'S CHEATING

The Coward's Way to Break Up

The face-to-face break up is the most honorable way to do it, but it's also a 10 on the discomfort scale. Texting is the least honorable way, but it's the easiest. Most anime guys choose texting, not realizing that it will create a tsunami of fury on the receiving end that will have consequences.

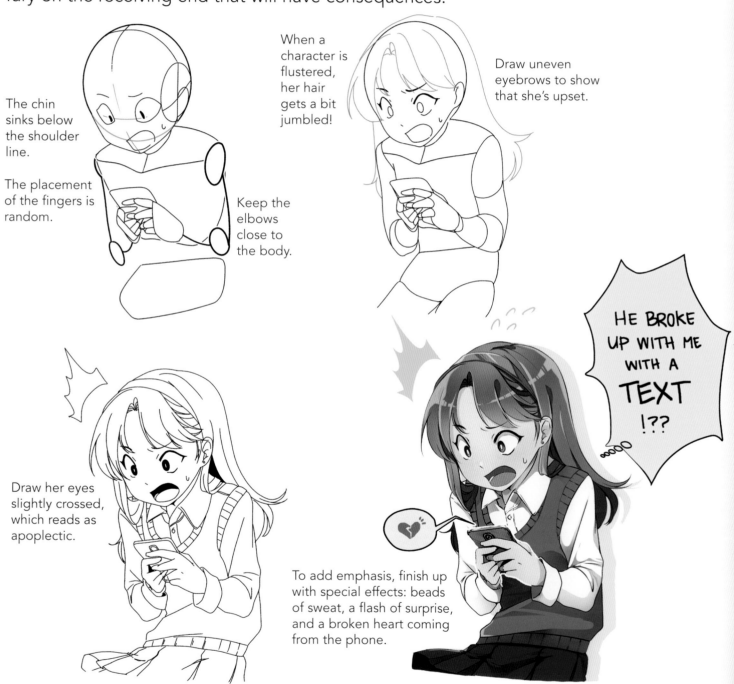

The chin sinks below the shoulder line.

The placement of the fingers is random.

Keep the elbows close to the body.

When a character is flustered, her hair gets a bit jumbled!

Draw uneven eyebrows to show that she's upset.

Draw her eyes slightly crossed, which reads as apoplectic.

To add emphasis, finish up with special effects: beads of sweat, a flash of surprise, and a broken heart coming from the phone.

HE BROKE UP WITH ME WITH A TEXT !??

Being Invisible

There's only one thing worse than being rejected: not being noticed at all. What's an average guy to do? He's not a football star, he's not rich, and he's not a genius. That leaves just one option for getting noticed: borrow the neighbor's puppy and walk it to school!

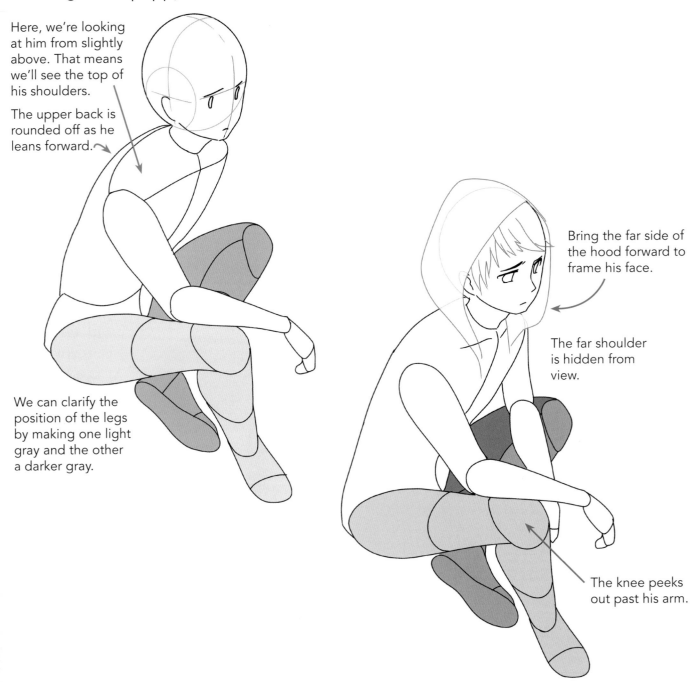

Here, we're looking at him from slightly above. That means we'll see the top of his shoulders.

The upper back is rounded off as he leans forward.

We can clarify the position of the legs by making one light gray and the other a darker gray.

Bring the far side of the hood forward to frame his face.

The far shoulder is hidden from view.

The knee peeks out past his arm.

A hood isn't only a fashion statement. Sometimes it's a visual metaphor used to show a character who feels isolated and alone.

Drawing the seam line of the pants helps the viewer conceptualize the pant leg in a bent position.

By using a variety of color tones, you give the impression that there are more colors than there actually are. For this outfit there are only two: gray and red.

She doesn't even know I'm alive ...

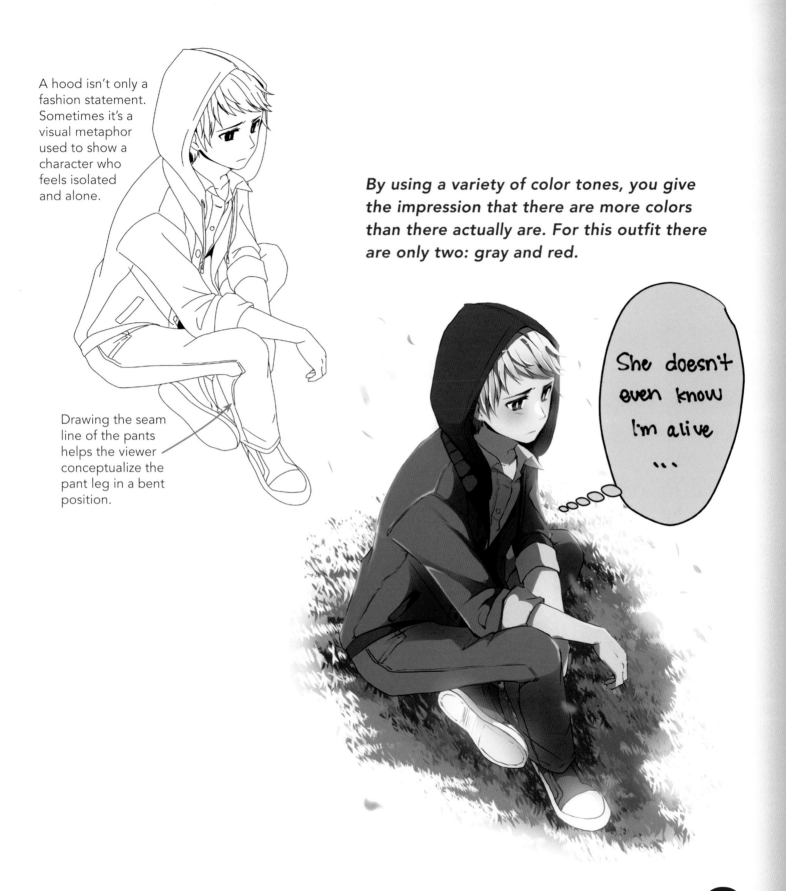

When It's Really Over

When a relationship ends, it's sad. But a break up is not without a silver lining. Usually, a break up is followed by watching TV movies while eating from a pint-sized tub of ice cream. Just to be clear: You don't have to wait for a breakup in order to eat ice cream directly out of the container, but it's an excellent excuse to do it.

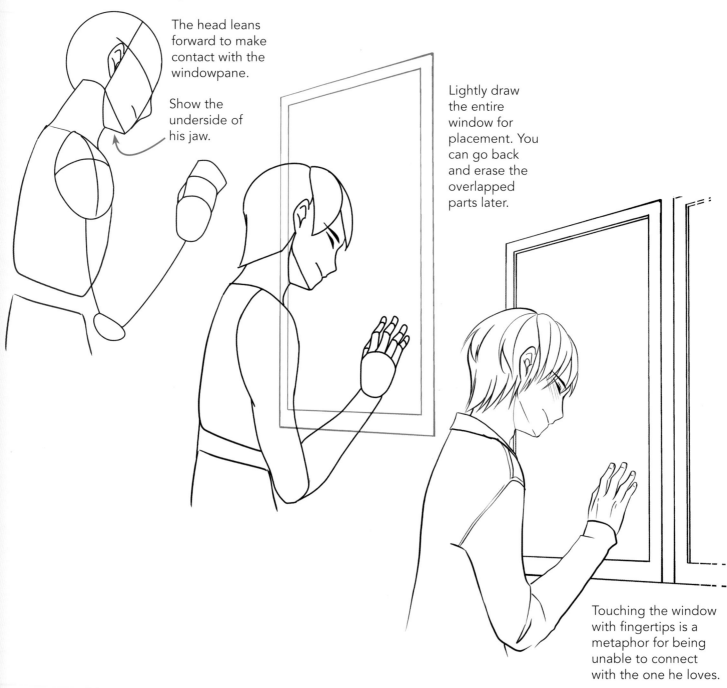

The head leans forward to make contact with the windowpane.

Show the underside of his jaw.

Lightly draw the entire window for placement. You can go back and erase the overlapped parts later.

Touching the window with fingertips is a metaphor for being unable to connect with the one he loves.

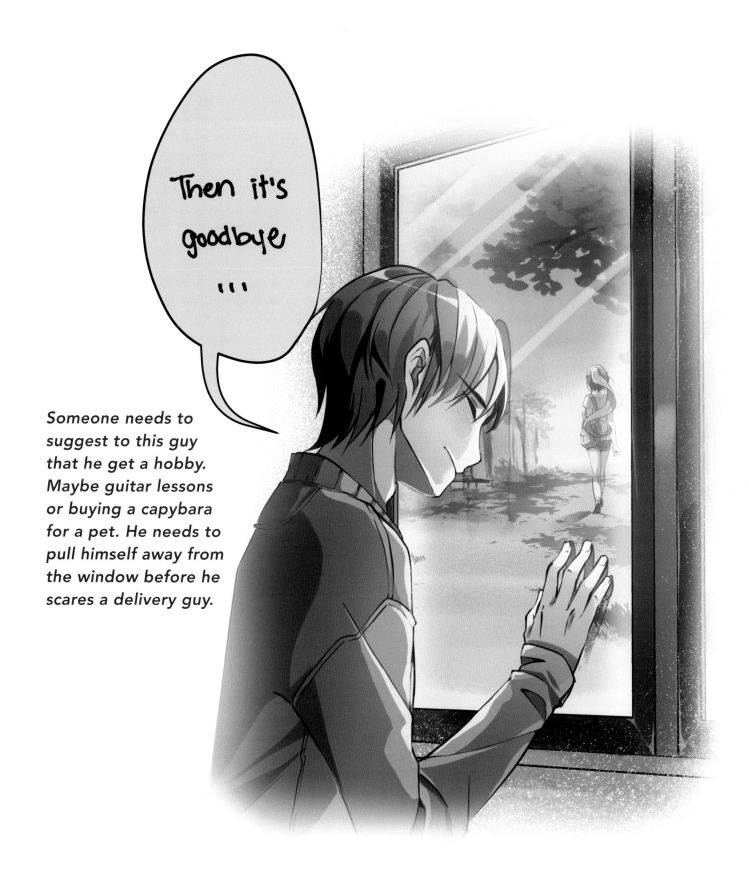

Then it's goodbye ...

Someone needs to suggest to this guy that he get a hobby. Maybe guitar lessons or buying a capybara for a pet. He needs to pull himself away from the window before he scares a delivery guy.

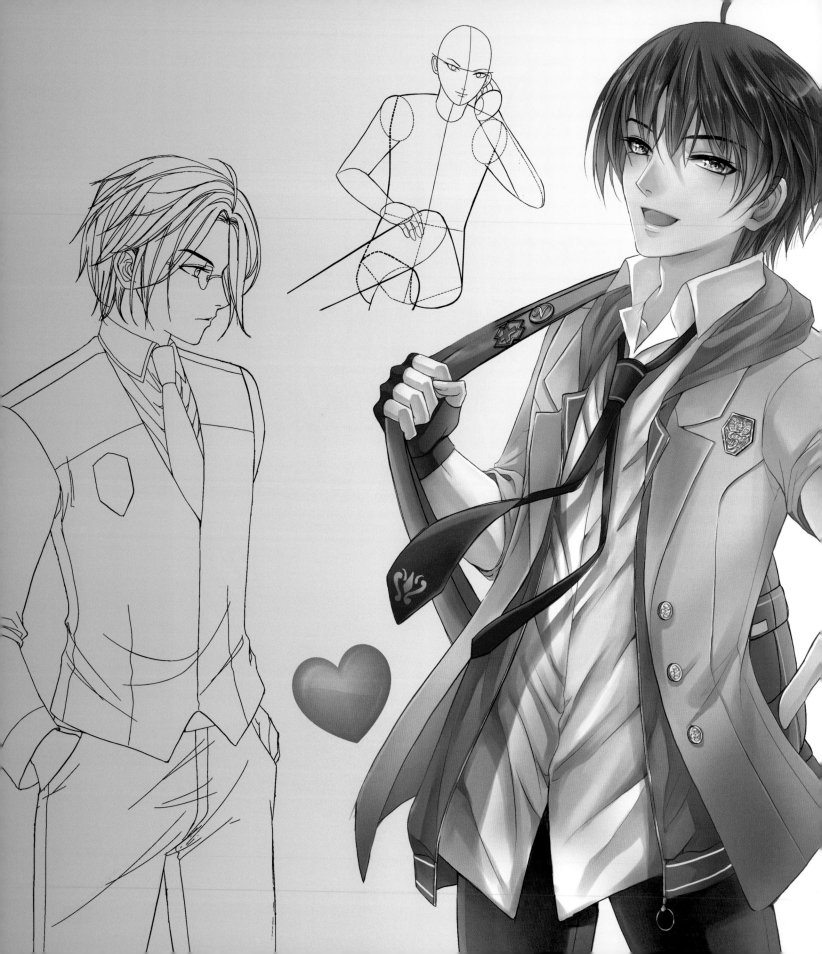

Building the Perfect Boyfriend

To create a boyfriend character, start by choosing a personality type, such as the quiet teen who stands apart from the crowd. He's a private type, which makes him intriguing. Give him idealized proportions. He's a little taller, a little leaner, and a little wider at the shoulders. His face has engaging, elegant eyes. There are many other personality types to play with too, such as the charismatic hero or the sensitive type. This chapter provides a good selection of boyfriends to get you started.

Traditional Boyfriend (Helpful Type)

This helpful character always has a warm smile and a pleasant mood. So what's the problem? The problem is he's helpful to everyone—including other girls. But that's okay—in anime, bumpy relationships are more interesting than relationships where everything goes smoothly.

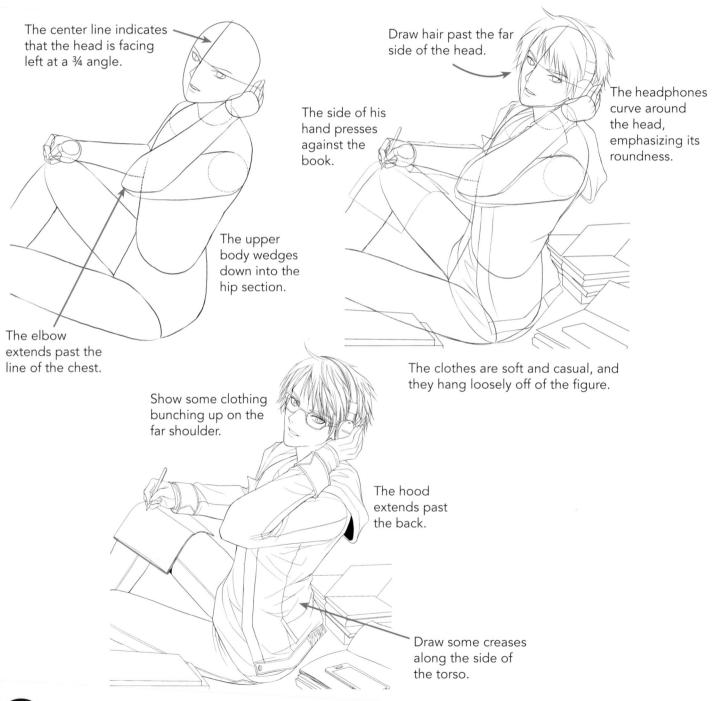

The center line indicates that the head is facing left at a ¾ angle.

The elbow extends past the line of the chest.

The side of his hand presses against the book.

The upper body wedges down into the hip section.

Draw hair past the far side of the head.

The headphones curve around the head, emphasizing its roundness.

The clothes are soft and casual, and they hang loosely off of the figure.

Show some clothing bunching up on the far shoulder.

The hood extends past the back.

Draw some creases along the side of the torso.

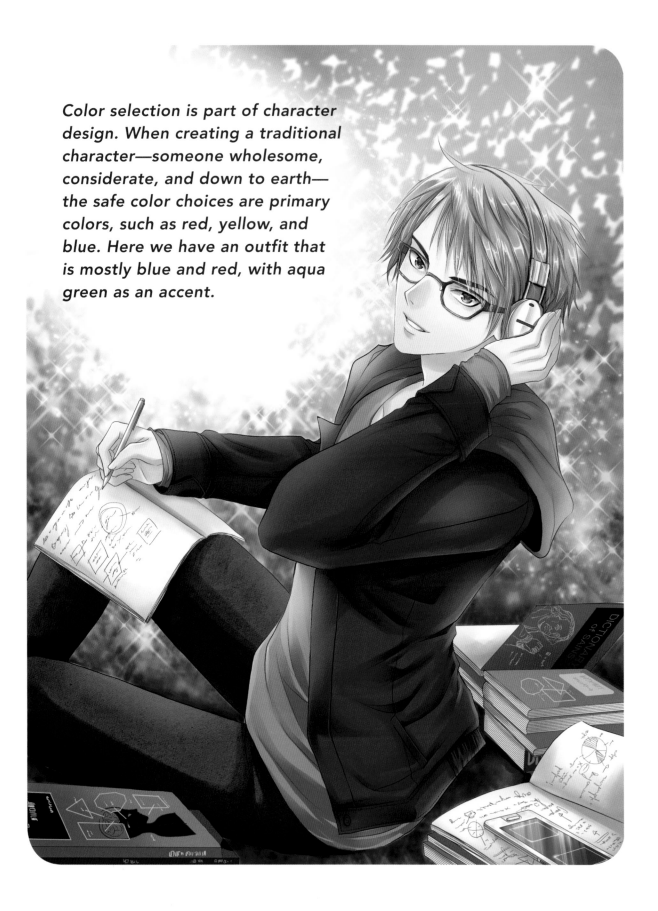

Color selection is part of character design. When creating a traditional character—someone wholesome, considerate, and down to earth— the safe color choices are primary colors, such as red, yellow, and blue. Here we have an outfit that is mostly blue and red, with aqua green as an accent.

Fantasy Boyfriend

This is a super-popular type in anime. He may be exciting to be around, but how much does the main character really know about him? Don't let the audience figure him out too soon. The fun is in the uncertainty. Does the girl believe his reassuring smile and breezy manner, or does she share her parents' reservations about him? This may be one of those times when her gut tells her that her parents are right. Don't you hate when that happens?

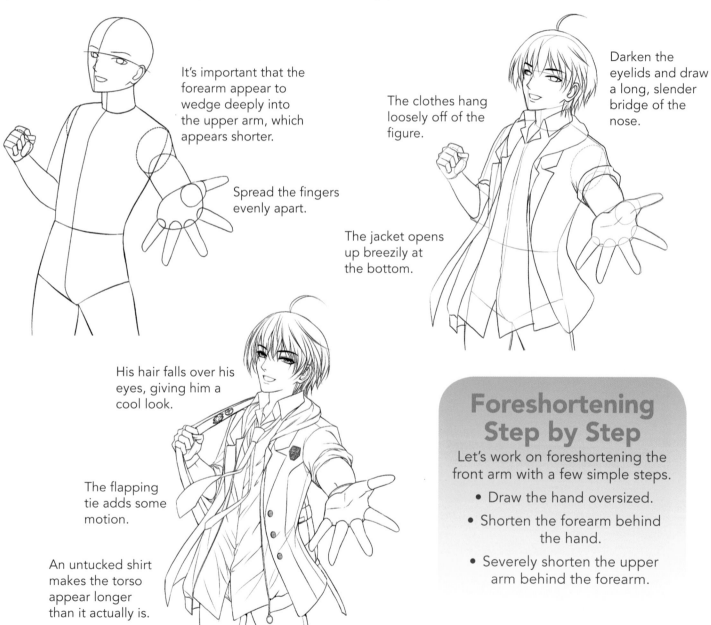

It's important that the forearm appear to wedge deeply into the upper arm, which appears shorter.

Spread the fingers evenly apart.

The clothes hang loosely off of the figure.

Darken the eyelids and draw a long, slender bridge of the nose.

The jacket opens up breezily at the bottom.

His hair falls over his eyes, giving him a cool look.

The flapping tie adds some motion.

An untucked shirt makes the torso appear longer than it actually is.

Foreshortening Step by Step

Let's work on foreshortening the front arm with a few simple steps.

- Draw the hand oversized.
- Shorten the forearm behind the hand.
- Severely shorten the upper arm behind the forearm.

72

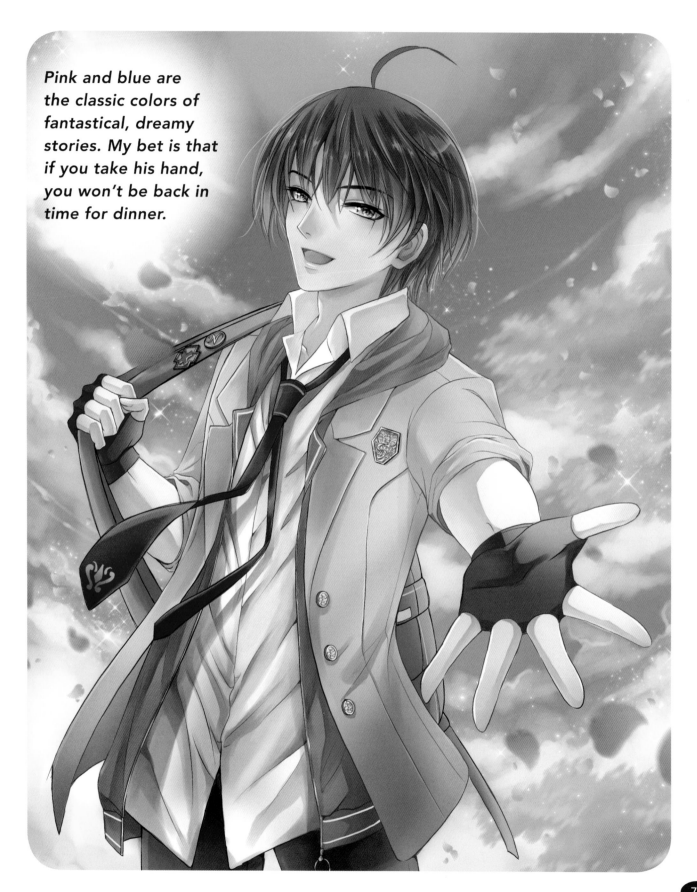

Pink and blue are the classic colors of fantastical, dreamy stories. My bet is that if you take his hand, you won't be back in time for dinner.

The Quiet Guy

What is it about the quiet guy character that's so popular? Other guys wear tattoos and weird hair and never get noticed. But a quiet guy enters a room and everyone pays attention! These quiet characters are usually tall and lanky, slightly brooding, and trim with angular faces.

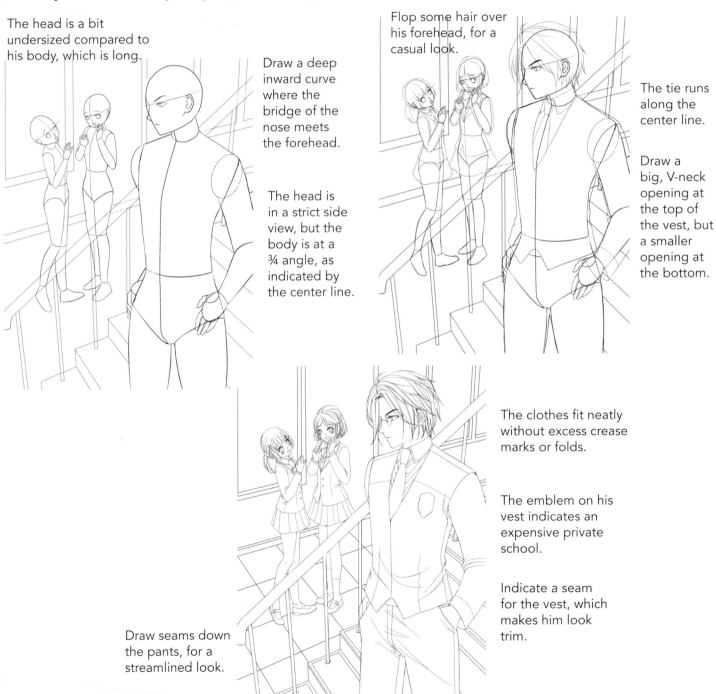

The head is a bit undersized compared to his body, which is long.

Draw a deep inward curve where the bridge of the nose meets the forehead.

The head is in a strict side view, but the body is at a ¾ angle, as indicated by the center line.

Flop some hair over his forehead, for a casual look.

The tie runs along the center line.

Draw a big, V-neck opening at the top of the vest, but a smaller opening at the bottom.

The clothes fit neatly without excess crease marks or folds.

The emblem on his vest indicates an expensive private school.

Indicate a seam for the vest, which makes him look trim.

Draw seams down the pants, for a streamlined look.

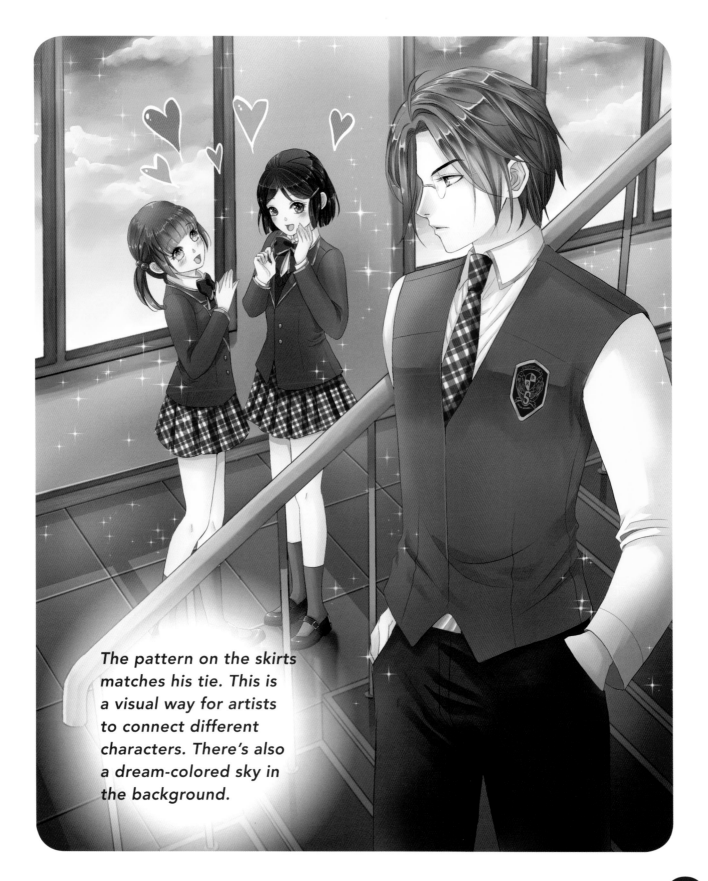

The pattern on the skirts matches his tie. This is a visual way for artists to connect different characters. There's also a dream-colored sky in the background.

Pop Star

Question: Who do girls have the biggest crushes on? City zoning planners or pop stars? If you guessed the first one, you need to watch more anime. Pop stars need only smile at a crowd of 50,000 screaming fans to cause each girl to believe he meant it just for her. An entertainer's clothes, hair, and moves are always flashy and entertaining.

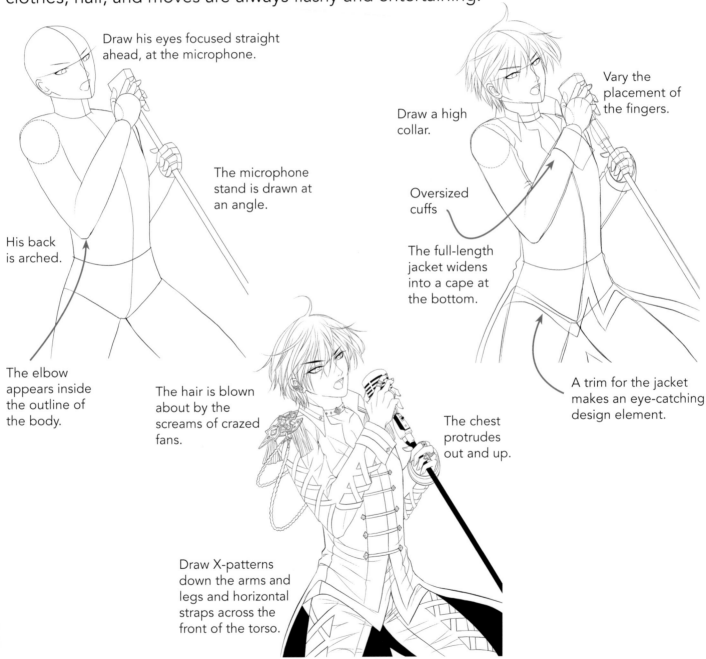

Draw his eyes focused straight ahead, at the microphone.

The microphone stand is drawn at an angle.

His back is arched.

The elbow appears inside the outline of the body.

Vary the placement of the fingers.

Draw a high collar.

Oversized cuffs

The full-length jacket widens into a cape at the bottom.

A trim for the jacket makes an eye-catching design element.

The hair is blown about by the screams of crazed fans.

The chest protrudes out and up.

Draw X-patterns down the arms and legs and horizontal straps across the front of the torso.

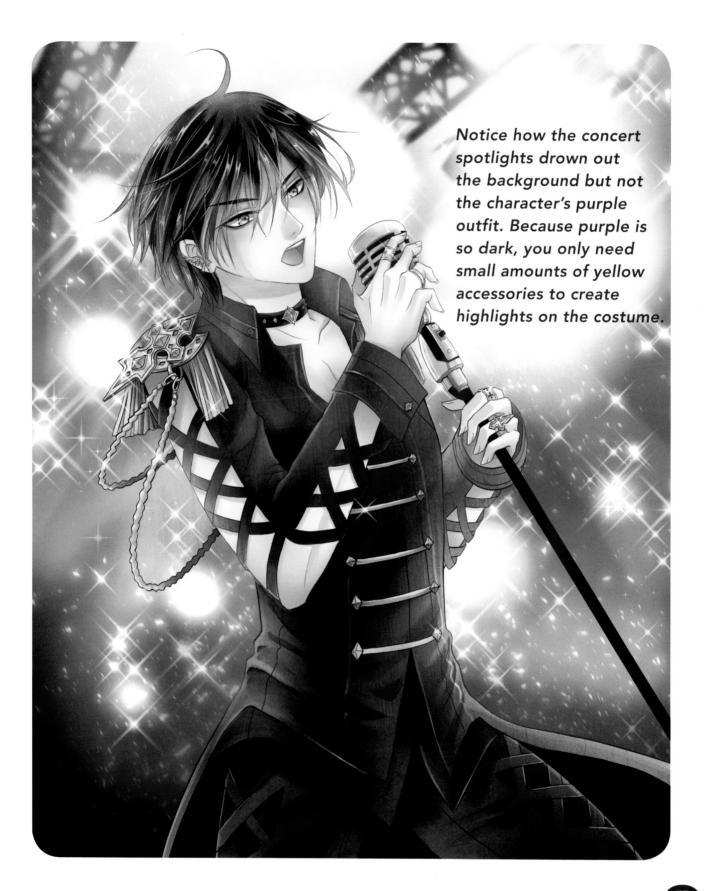

Notice how the concert spotlights drown out the background but not the character's purple outfit. Because purple is so dark, you only need small amounts of yellow accessories to create highlights on the costume.

Nobility

The upper crust makes popular boyfriend material. I wonder why that is. Maybe it's how they play soccer? Or their smile? Or the fact that they're very rich and have a castle? There's one small problem with marrying a prince—you have to be a princess. It's not easy to get around that requirement, but if you somehow do, get ready to battle with your new mother-in-law, the queen.

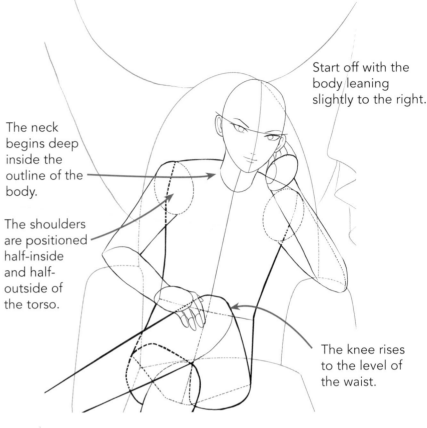

Start off with the body leaning slightly to the right.

The neck begins deep inside the outline of the body.

The shoulders are positioned half-inside and half-outside of the torso.

The knee rises to the level of the waist.

Adding Decorative Touches

You can approximate the look of intricate stitching by substituting these simpler, decorative icons instead.

• Small jewel shapes like diamonds, squares, and ovals

• Icons such as stars, hearts, and quarter moons

• Thin gold chains

• Medallions

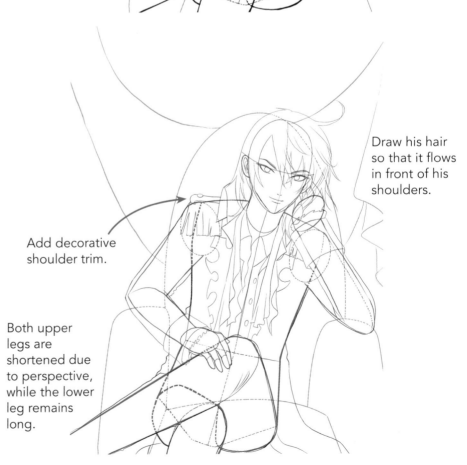

Draw his hair so that it flows in front of his shoulders.

Add decorative shoulder trim.

Both upper legs are shortened due to perspective, while the lower leg remains long.

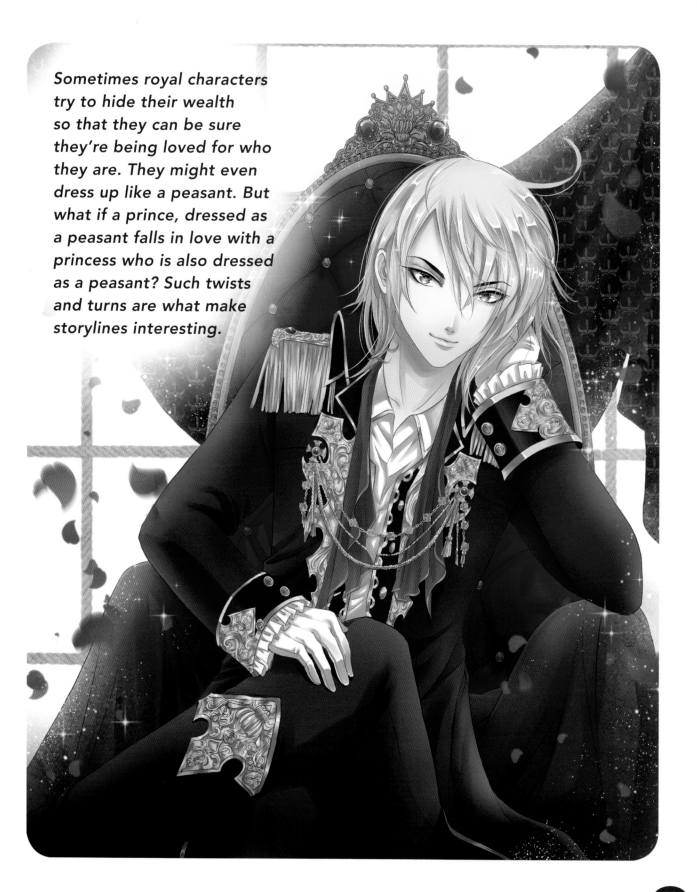

Sometimes royal characters try to hide their wealth so that they can be sure they're being loved for who they are. They might even dress up like a peasant. But what if a prince, dressed as a peasant falls in love with a princess who is also dressed as a peasant? Such twists and turns are what make storylines interesting.

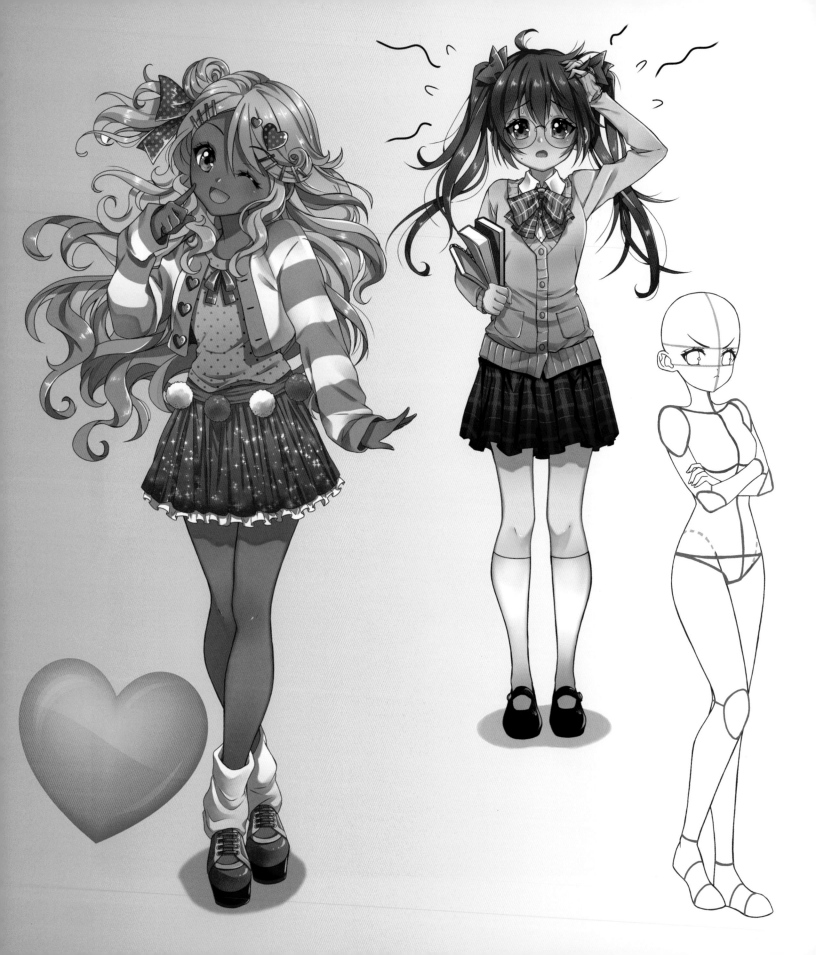

Romantic Comedy Characters ♡

Humorous characters are a staple in romantic comedies. They bring lighter moments to dramatic situations. Funny personalities tend to overreact to things. An example might be a girl who is generally reserved, but gets weepy whenever she sees something sentimental. The most effective way to create a comedic character is to select a simple personality type and then magnify that personality trait. We'll draw a host of popular comedy types in this chapter by increasing the four main areas of character design: expression, hairstyle, outfit, and pose.

Stuck Up

If being self-absorbed is a stage she's going through, then she's going through it very, very slowly. Every day starts out with a thorough search across social media to see if anyone mentioned her name. If not, she can always review previous posts. It makes such good reading!

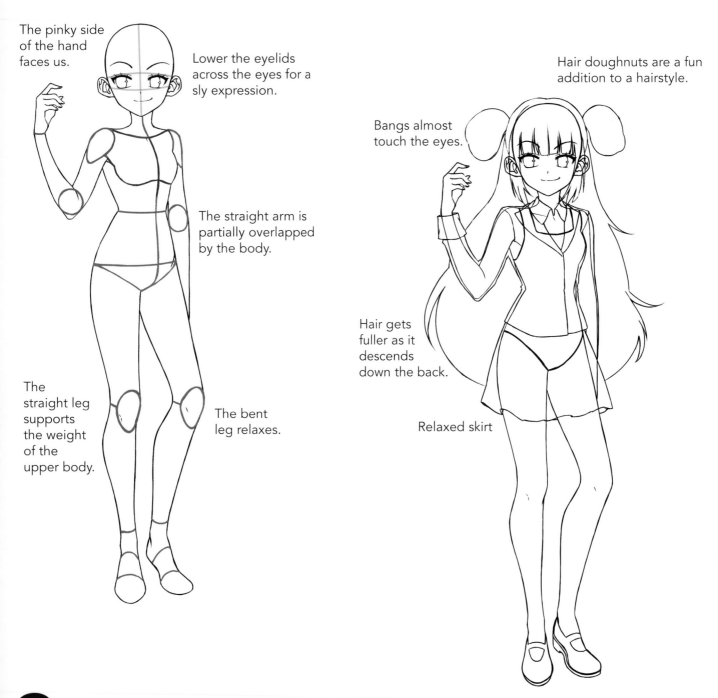

The pinky side of the hand faces us.

Lower the eyelids across the eyes for a sly expression.

The straight arm is partially overlapped by the body.

The straight leg supports the weight of the upper body.

The bent leg relaxes.

Hair doughnuts are a fun addition to a hairstyle.

Bangs almost touch the eyes.

Hair gets fuller as it descends down the back.

Relaxed skirt

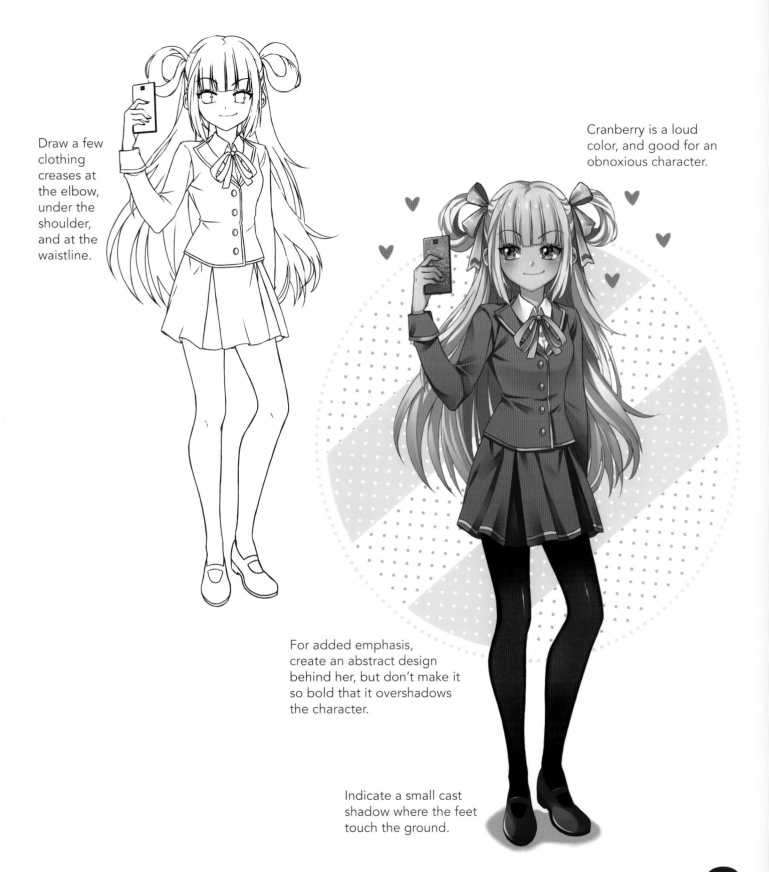

Draw a few clothing creases at the elbow, under the shoulder, and at the waistline.

Cranberry is a loud color, and good for an obnoxious character.

For added emphasis, create an abstract design behind her, but don't make it so bold that it overshadows the character.

Indicate a small cast shadow where the feet touch the ground.

Resentful

Her expression is pouty, but her pose is defiant. She's also sneaky and sometimes pretends to be looking out for her friend while betraying her. This character creates ongoing tension, which is important in a story. If there's no tension, the viewers lose interest.

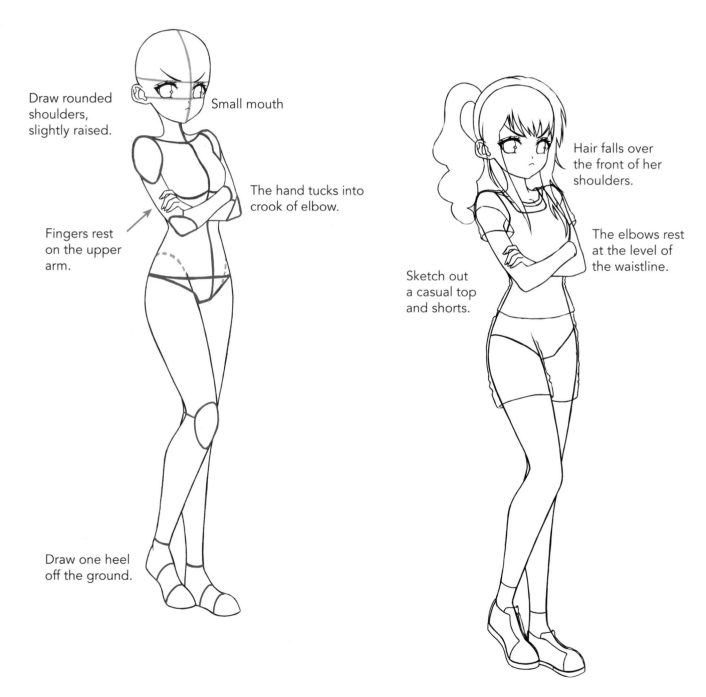

Draw rounded shoulders, slightly raised.

Small mouth

The hand tucks into crook of elbow.

Fingers rest on the upper arm.

Draw one heel off the ground.

Hair falls over the front of her shoulders.

The elbows rest at the level of the waistline.

Sketch out a casual top and shorts.

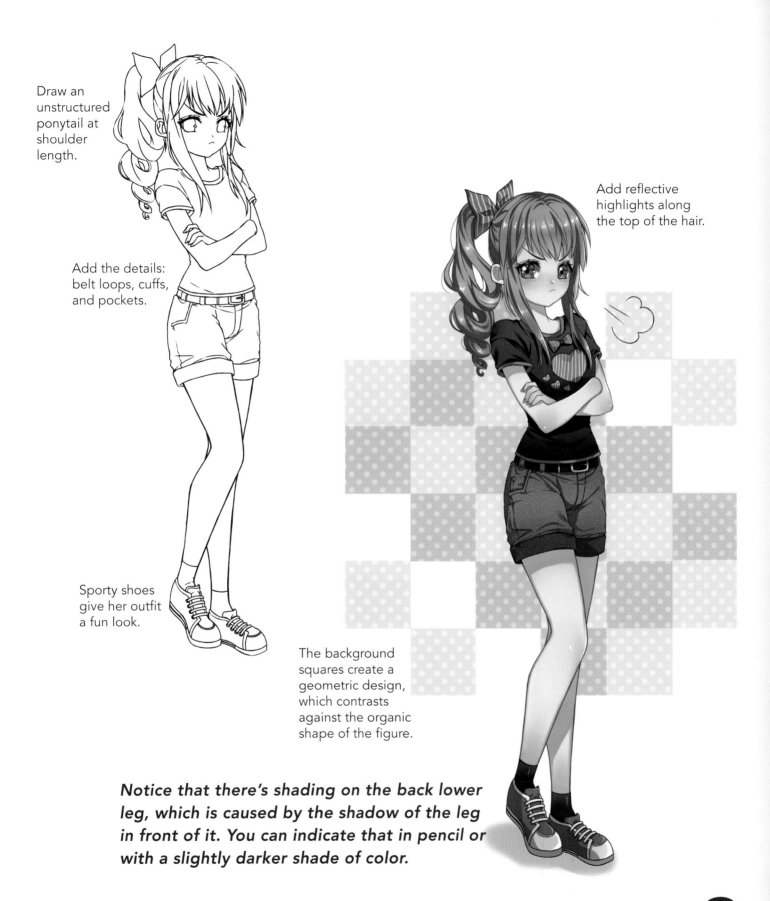

Draw an unstructured ponytail at shoulder length.

Add the details: belt loops, cuffs, and pockets.

Sporty shoes give her outfit a fun look.

Add reflective highlights along the top of the hair.

The background squares create a geometric design, which contrasts against the organic shape of the figure.

Notice that there's shading on the back lower leg, which is caused by the shadow of the leg in front of it. You can indicate that in pencil or with a slightly darker shade of color.

Chatterbox

Never tell this character a secret. It would be the same as posting it on social media. The chatterbox character believes she's very good at keeping a secret. It's just that she keeps it among many people at the same time.

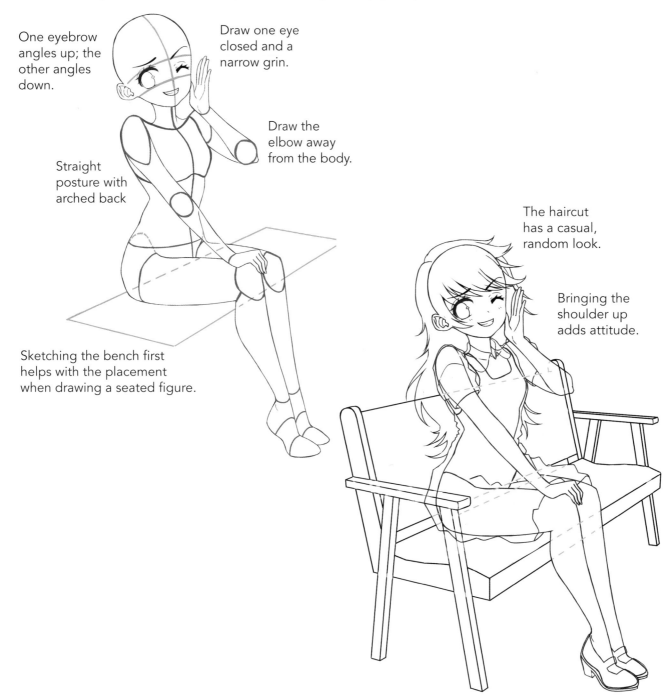

One eyebrow angles up; the other angles down.

Draw one eye closed and a narrow grin.

Draw the elbow away from the body.

Straight posture with arched back

Sketching the bench first helps with the placement when drawing a seated figure.

The haircut has a casual, random look.

Bringing the shoulder up adds attitude.

Draw a bow in the hair, cuffs on the short sleeves, and a tie around the collar.

Draw creases and folds along the bottom half of the dress.

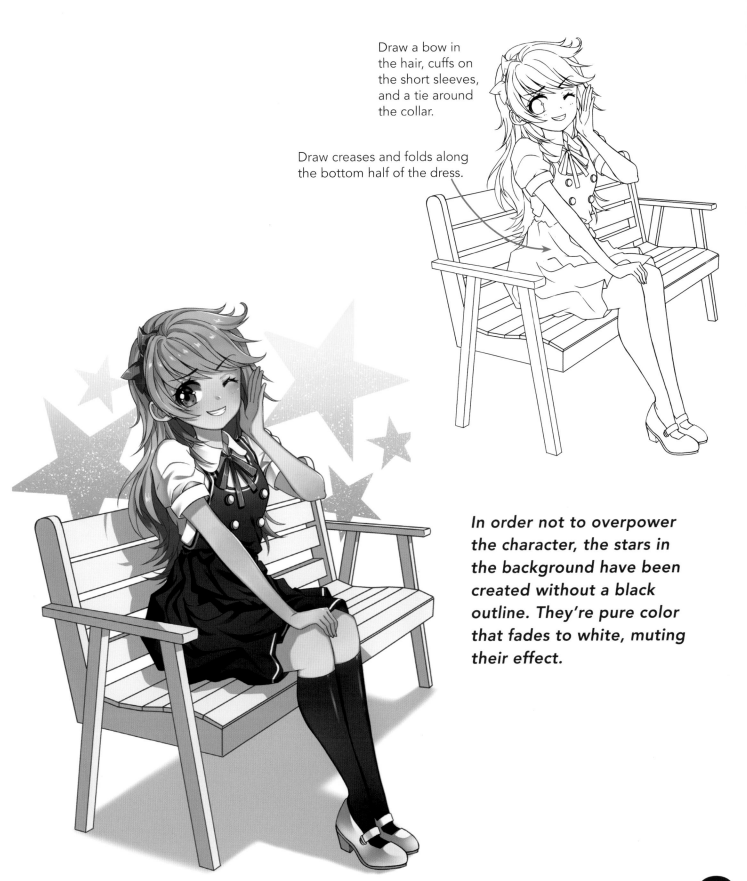

In order not to overpower the character, the stars in the background have been created without a black outline. They're pure color that fades to white, muting their effect.

The Poser

This type is known for striking a pose anytime someone cute walks by. She acts as if it were impromptu. But not a single person on planet Earth believes her.

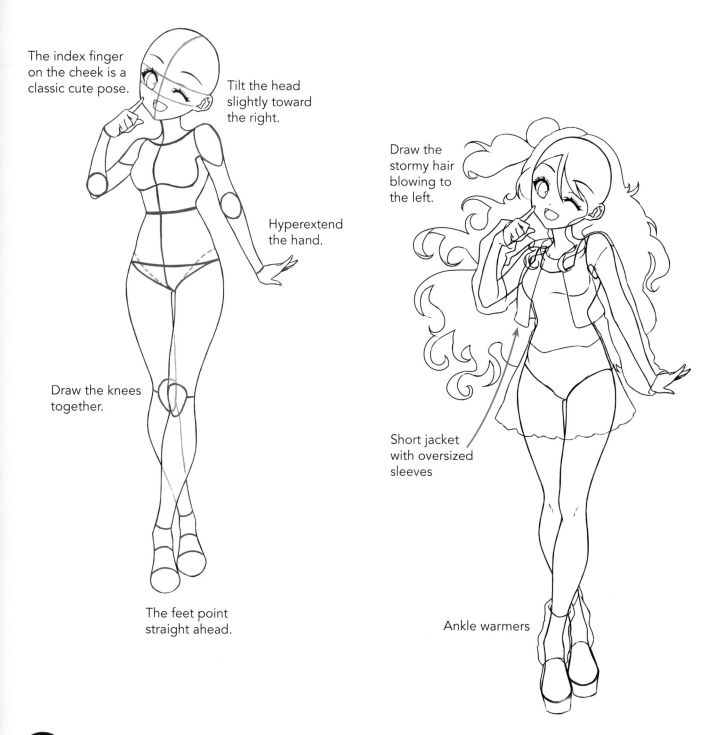

The index finger on the cheek is a classic cute pose.

Tilt the head slightly toward the right.

Hyperextend the hand.

Draw the knees together.

The feet point straight ahead.

Draw the stormy hair blowing to the left.

Short jacket with oversized sleeves

Ankle warmers

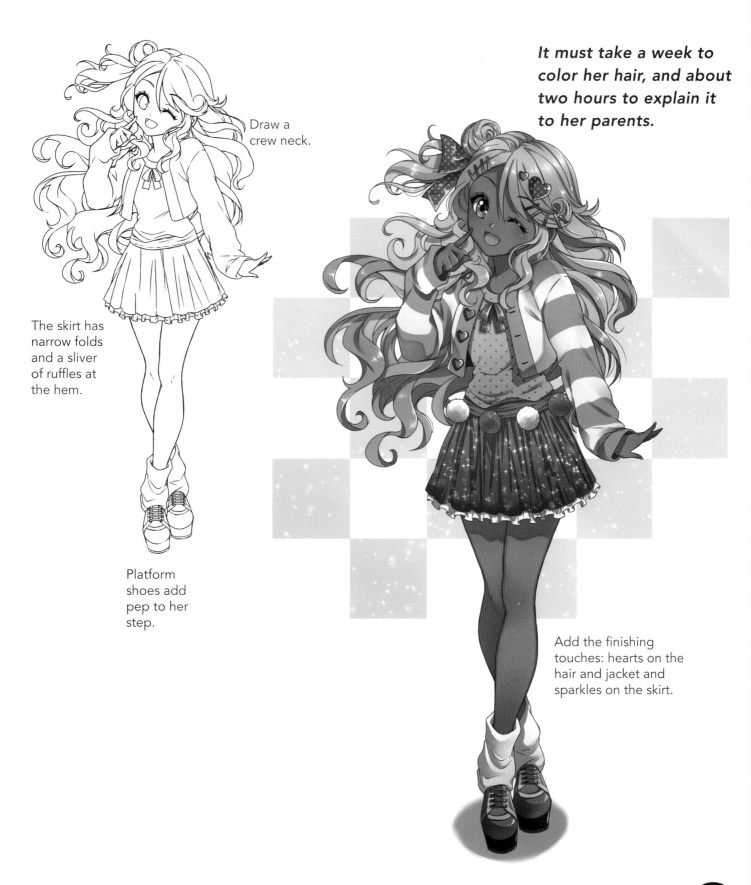

Draw a crew neck.

The skirt has narrow folds and a sliver of ruffles at the hem.

Platform shoes add pep to her step.

It must take a week to color her hair, and about two hours to explain it to her parents.

Add the finishing touches: hearts on the hair and jacket and sparkles on the skirt.

Worrier

The worrier gets nervous about everything. What if she had a piece of spinach in her teeth when she was speaking to her crush? And he noticed it? What if he thought it looked nice? What if she has a weird crush?

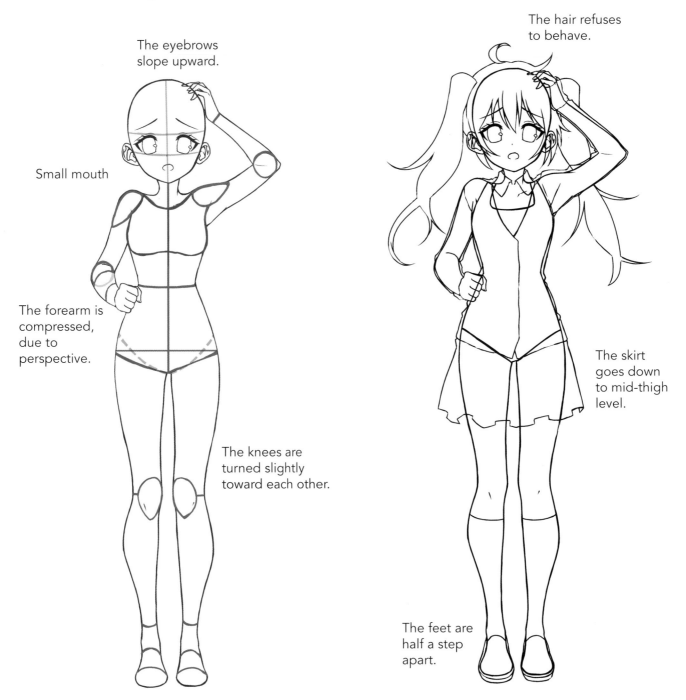

The eyebrows slope upward.

The hair refuses to behave.

Small mouth

The forearm is compressed, due to perspective.

The skirt goes down to mid-thigh level.

The knees are turned slightly toward each other.

The feet are half a step apart.

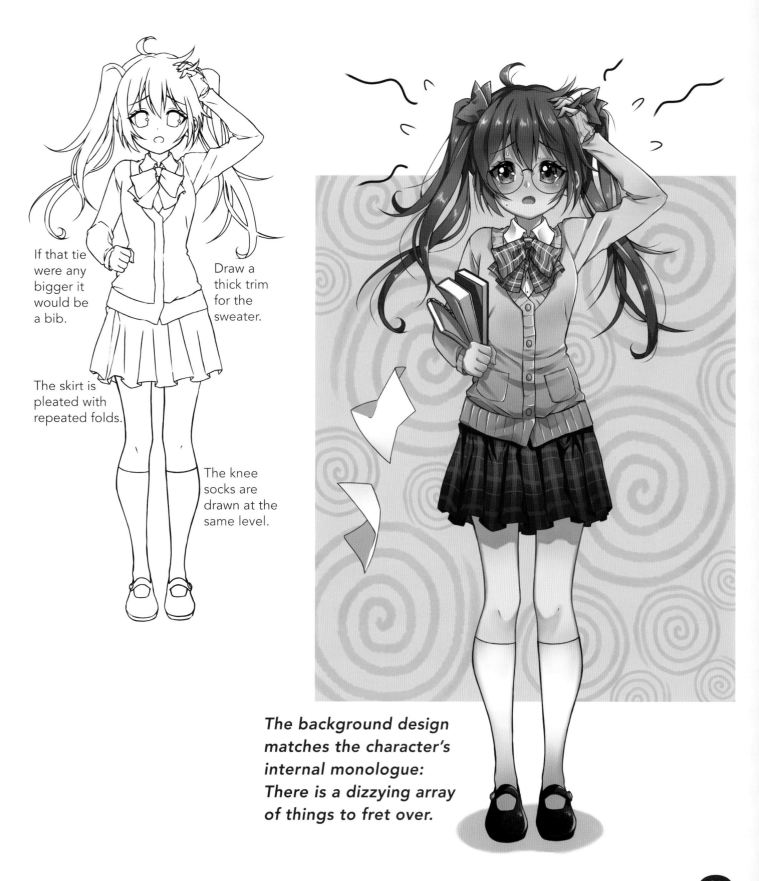

If that tie were any bigger it would be a bib.

Draw a thick trim for the sweater.

The skirt is pleated with repeated folds.

The knee socks are drawn at the same level.

The background design matches the character's internal monologue: There is a dizzying array of things to fret over.

More Romance Genres

Love can strike anyone at anytime, and not just in romantic comedies. Whether it's a modern mystery, fantasy, or drama, all that's required are characters who are attracted to each other and a conflict that keeps them apart.

ROMANCE AND DRAMA

Good drama starts with a wistful pose, an outfit that sways as if it had a mind of its own, and hair that floats as if being pulled by a magnet.

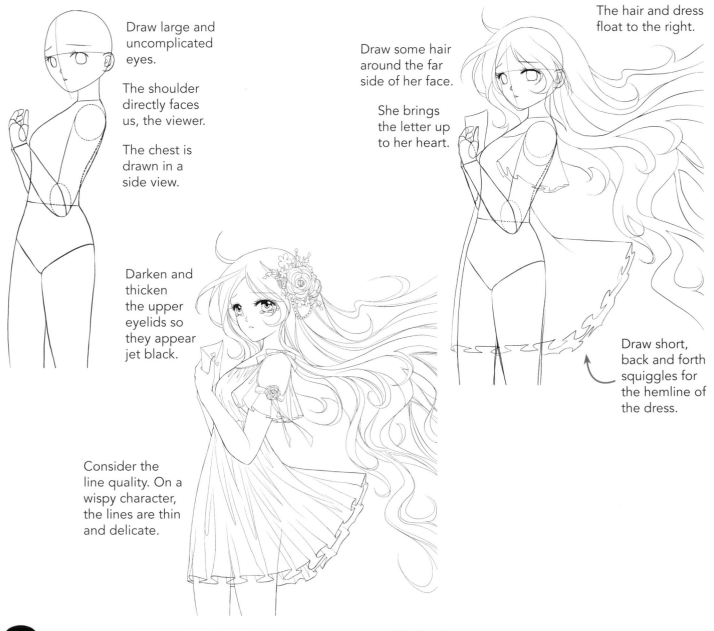

Draw large and uncomplicated eyes.

The shoulder directly faces us, the viewer.

The chest is drawn in a side view.

Draw some hair around the far side of her face.

She brings the letter up to her heart.

The hair and dress float to the right.

Darken and thicken the upper eyelids so they appear jet black.

Consider the line quality. On a wispy character, the lines are thin and delicate.

Draw short, back and forth squiggles for the hemline of the dress.

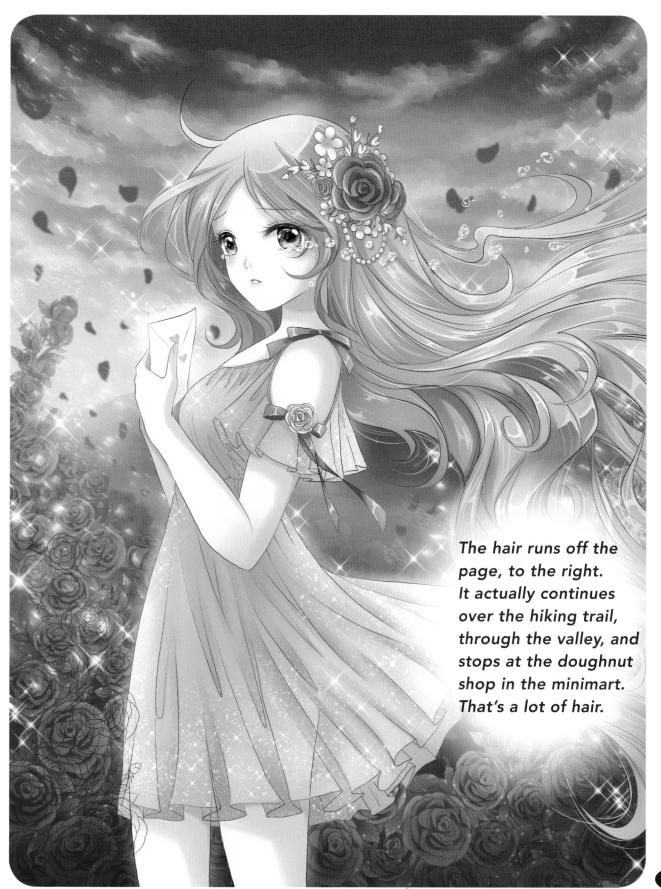

The hair runs off the page, to the right. It actually continues over the hiking trail, through the valley, and stops at the doughnut shop in the minimart. That's a lot of hair.

MYSTERY ROMANCE

In a typical mystery story, someone is on the trail of someone or something. Your main character meets another character along the way. Are they on the same side? Or are they adversaries, after the same prize? Want to increase the tension even more? Add a little romance. That always makes the suspicions more complicated.

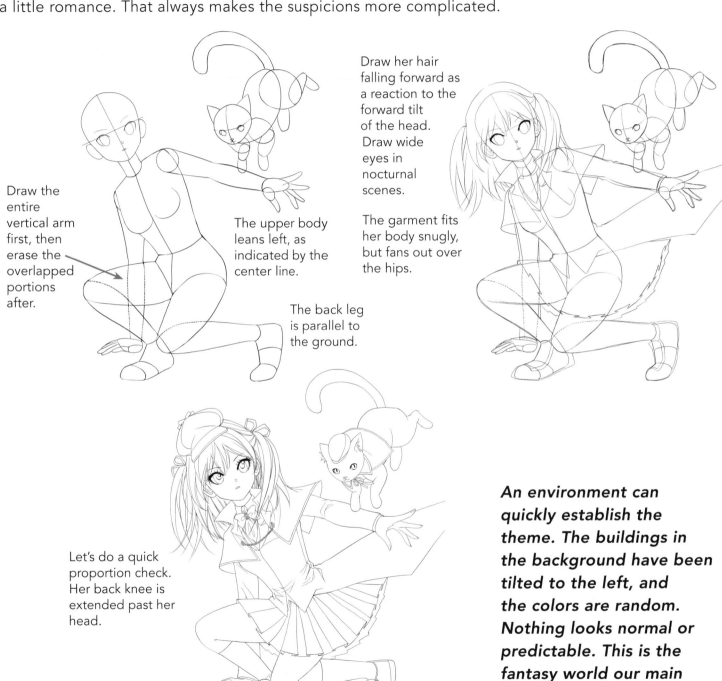

Draw the entire vertical arm first, then erase the overlapped portions after.

The upper body leans left, as indicated by the center line.

The back leg is parallel to the ground.

Draw her hair falling forward as a reaction to the forward tilt of the head. Draw wide eyes in nocturnal scenes.

The garment fits her body snugly, but fans out over the hips.

Let's do a quick proportion check. Her back knee is extended past her head.

An environment can quickly establish the theme. The buildings in the background have been tilted to the left, and the colors are random. Nothing looks normal or predictable. This is the fantasy world our main character has entered.

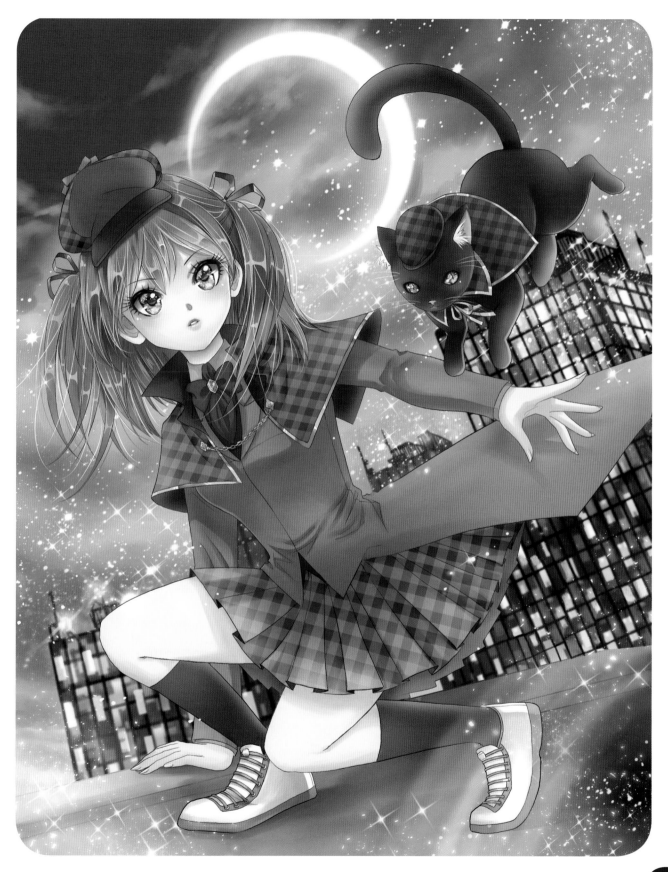

FANTASY ROMANCE (ELVES AND FAIRIES)

In the land of fairies, elves, and fantastic creatures, romance is very much alive. A fairy wedding is the driving force behind many stories, so a beautiful, fancy gown is essential. When you're only two inches tall, you can afford to buy the best material!

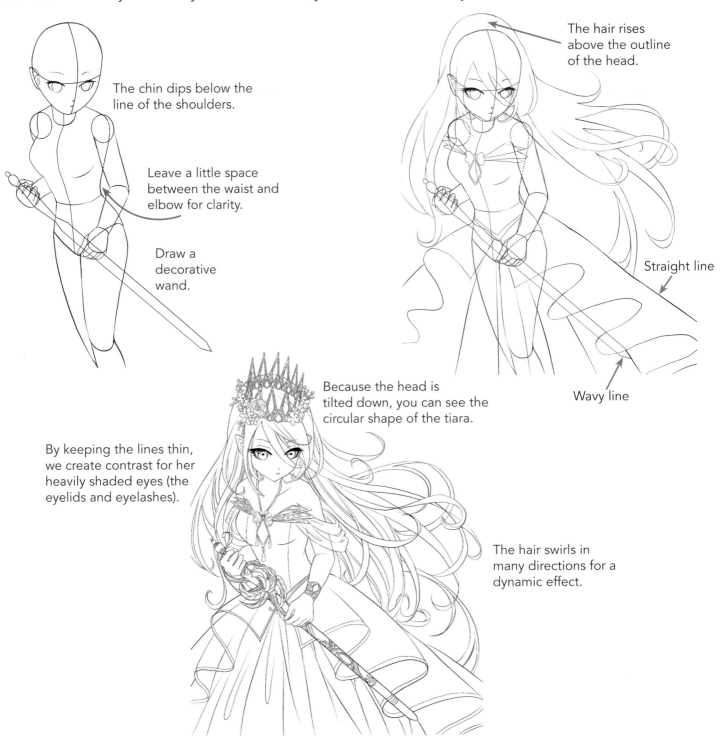

The chin dips below the line of the shoulders.

Leave a little space between the waist and elbow for clarity.

Draw a decorative wand.

The hair rises above the outline of the head.

Straight line

Wavy line

Because the head is tilted down, you can see the circular shape of the tiara.

By keeping the lines thin, we create contrast for her heavily shaded eyes (the eyelids and eyelashes).

The hair swirls in many directions for a dynamic effect.

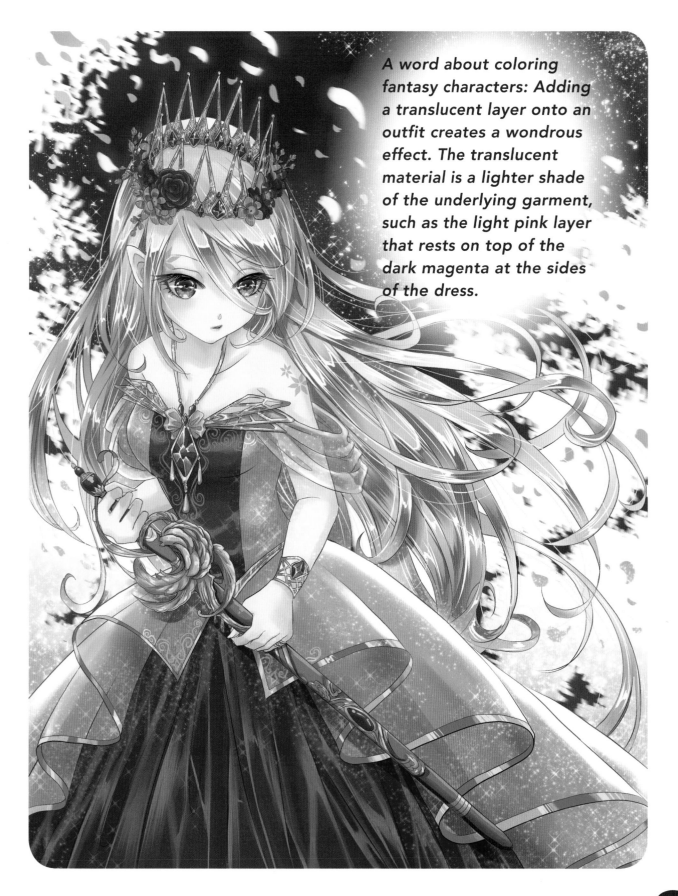

A word about coloring fantasy characters: Adding a translucent layer onto an outfit creates a wondrous effect. The translucent material is a lighter shade of the underlying garment, such as the light pink layer that rests on top of the dark magenta at the sides of the dress.

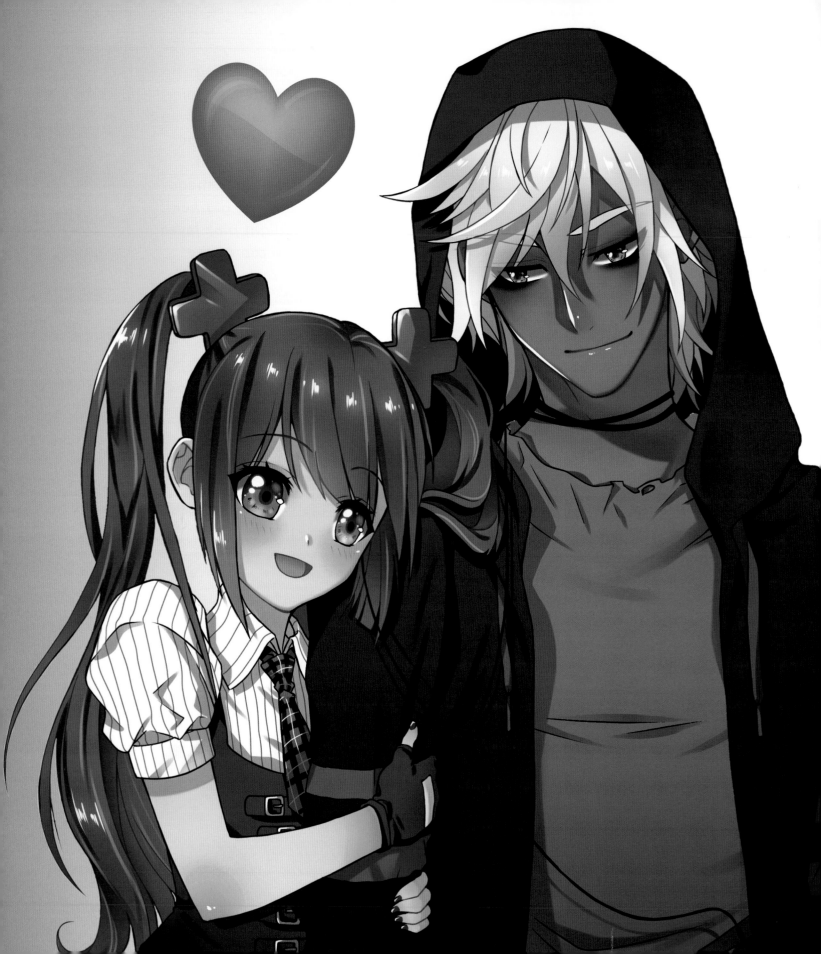

Drawing Couples Based on a Theme

The easiest way to create a match is to show two people with a common interest. Visual themes are a good choice. Even something cerebral, like two bookworms, can be made visual. For example, the characters could meet by accidentally bumping into each other while carrying a stack of books. While picking them up, he notices that she's reading what he's reading. A match! A shared theme doesn't have to remain the focus of the story. But it's a good device to get things rolling.

Pet Lovers

Pets are great icebreakers. While the two characters strike up a conversation about their pets, we begin to realize that the dogs set this up! Position the characters close to one another, but leave just enough space between them to keep the scene from looking cramped.

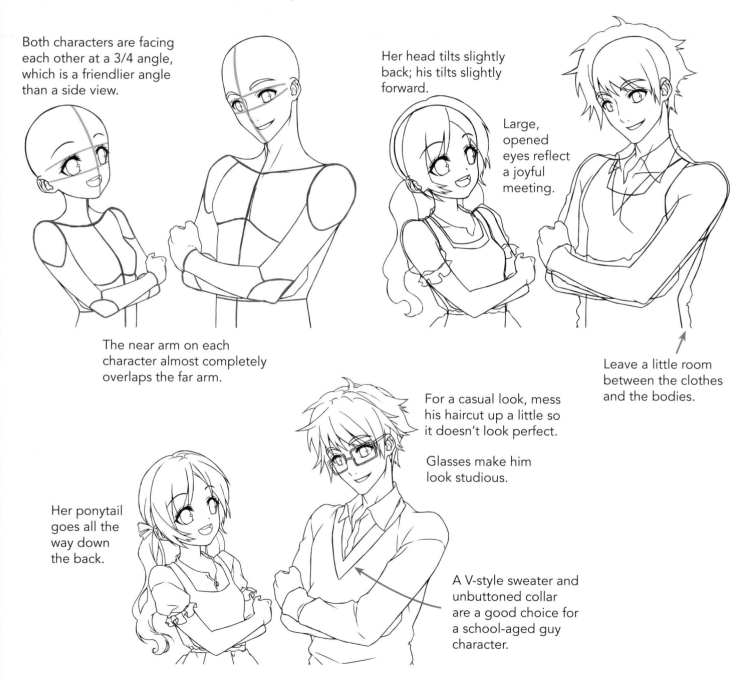

Both characters are facing each other at a 3/4 angle, which is a friendlier angle than a side view.

The near arm on each character almost completely overlaps the far arm.

Her head tilts slightly back; his tilts slightly forward.

Large, opened eyes reflect a joyful meeting.

Leave a little room between the clothes and the bodies.

For a casual look, mess his haircut up a little so it doesn't look perfect.

Glasses make him look studious.

Her ponytail goes all the way down the back.

A V-style sweater and unbuttoned collar are a good choice for a school-aged guy character.

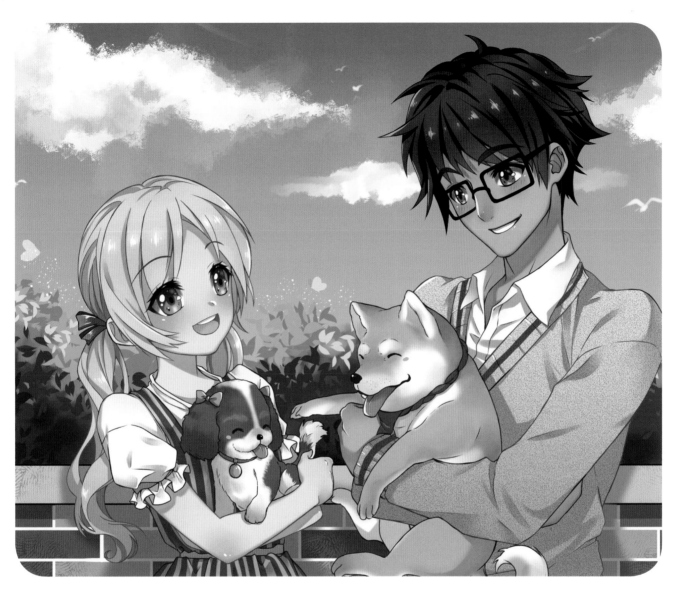

The dogs will be funnier if they aren't perfectly behaved.

The girl is doing the talking and the boy is doing the listening. Conversations flow smoother if the characters appear to take turns.

Opposites Attract

In anime, as in real life, opposites attract. His friends don't like her, and her friends don't like him. But they don't care! Both will end up at a good college, become famous on social media, and live happily ever after in a ridiculously expensive home. Bam!

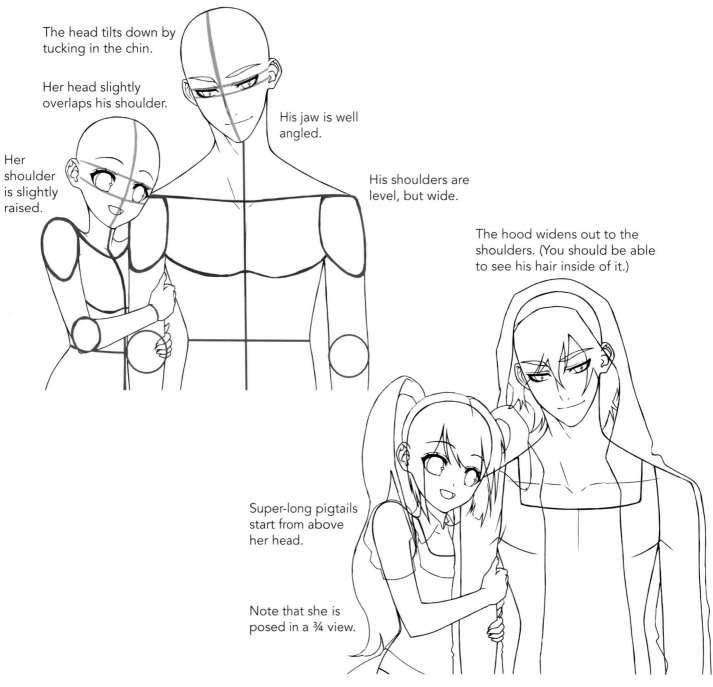

The head tilts down by tucking in the chin.

Her head slightly overlaps his shoulder.

Her shoulder is slightly raised.

His jaw is well angled.

His shoulders are level, but wide.

The hood widens out to the shoulders. (You should be able to see his hair inside of it.)

Super-long pigtails start from above her head.

Note that she is posed in a ¾ view.

Her hair falls over her forehead. Show her eyebrows through her bangs.

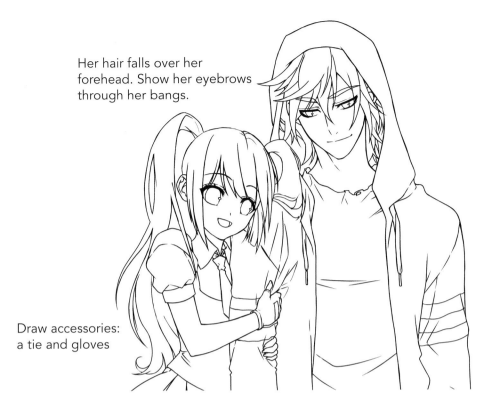

Draw accessories: a tie and gloves

Draw stripes on the sleeves of his jacket for a sporty look.

The color scheme connects them: They share a lot of blue and purple shades.

Decorative graffiti spells out the word LOVE, implying that these two are the heroes of the story.

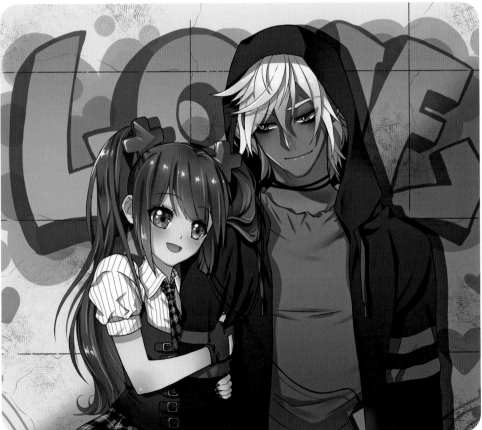

Cosplay Fans

Cosplay is a popular activity where fans dress up as their favorite characters to go to an anime convention. These two sci-fi warriors, for example, are meeting for the first time at a cosplay convention. Maybe they'll team up to save the world from falling into eternal darkness. On the other hand, getting a couple of fruit smoothies might be an even better start.

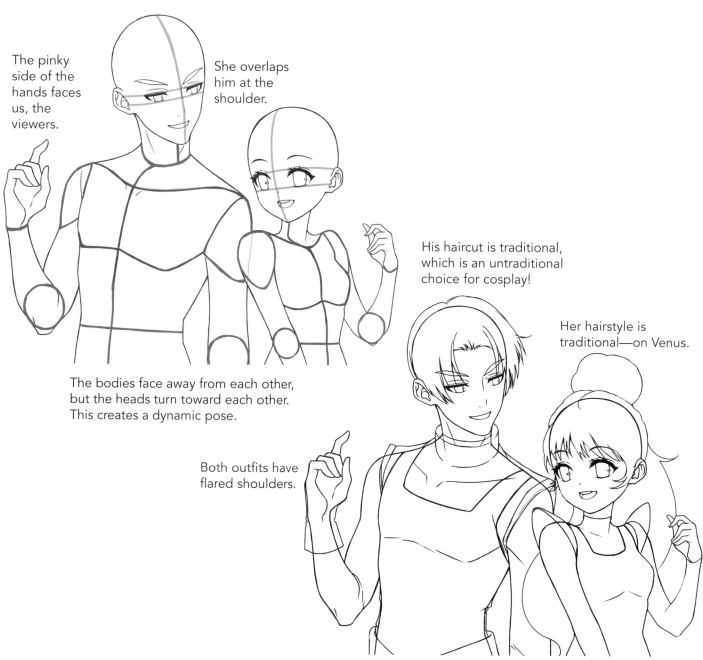

The pinky side of the hands faces us, the viewers.

She overlaps him at the shoulder.

His haircut is traditional, which is an untraditional choice for cosplay!

Her hairstyle is traditional—on Venus.

The bodies face away from each other, but the heads turn toward each other. This creates a dynamic pose.

Both outfits have flared shoulders.

104

He wears a univision eye piece. What does it do? Beats me.

Her magical staff is for warding off ogres and evil creatures. It seems to be working.

That device looks like an intergalactic weapon, but it's actually used to start a barbecue grill.

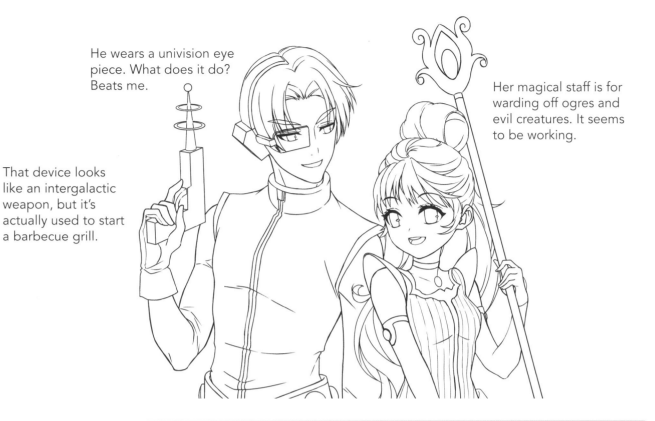

Aqua-blue, purple, pink, and magenta combine to create a sci-fi theme.

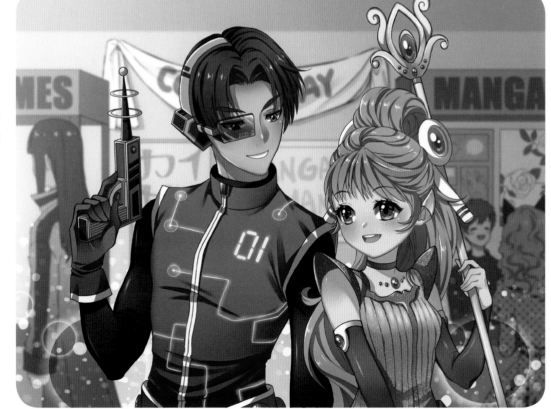

The Five Stages of Dating

Dating doesn't always go smoothly. In fact, it can go completely awry. Rather than solving romantic problems, anime artists and writers highlight the conflicts in order to bring out the humor of a situation. Remember that conflict always follows calm, and calm follows conflict. It's a cycle that keeps audiences interested.

STARTING OUT: BLISSFULLY IN LOVE

Blissful encounters happen early in a relationship and seem as if they will never end. This ballroom dance feels like it could go on forever.

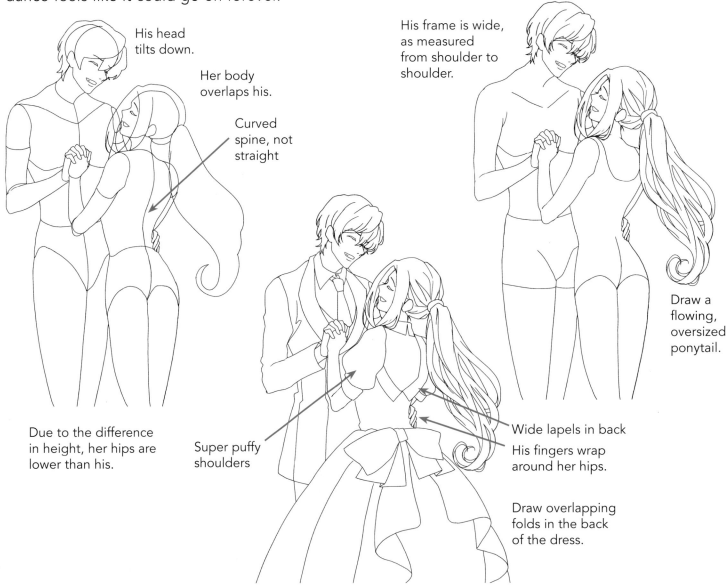

His head tilts down.

Her body overlaps his.

Curved spine, not straight

His frame is wide, as measured from shoulder to shoulder.

Draw a flowing, oversized ponytail.

Due to the difference in height, her hips are lower than his.

Super puffy shoulders

Wide lapels in back

His fingers wrap around her hips.

Draw overlapping folds in the back of the dress.

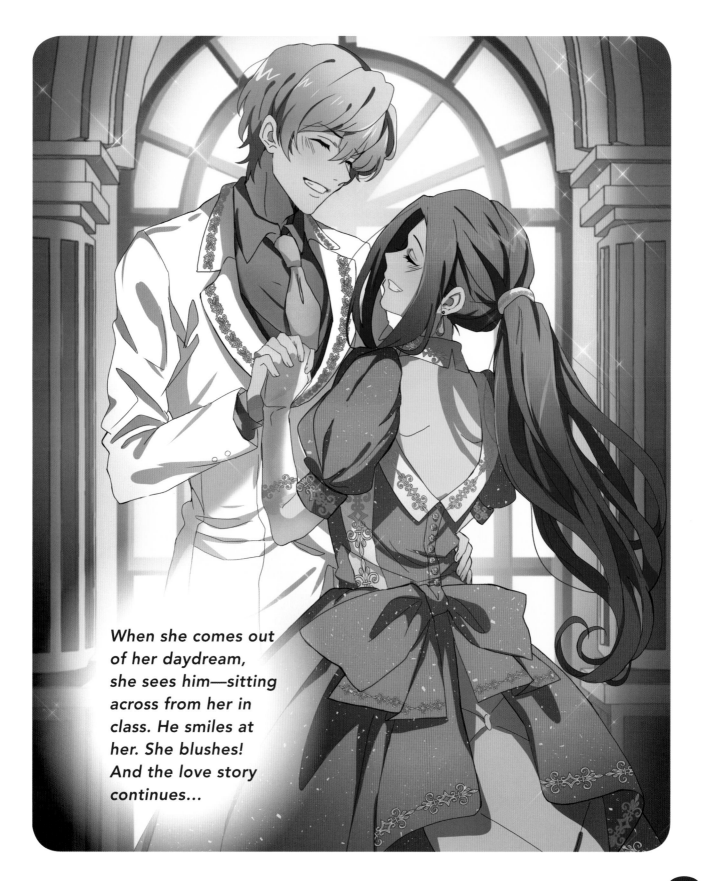

When she comes out of her daydream, she sees him—sitting across from her in class. He smiles at her. She blushes! And the love story continues...

FIGHTING AND ARGUING

What happened to the perfect sunsets and purple rainbows? As predicted, disharmony has reared its head. Arguments are usually about nothing important—at least to one of them.

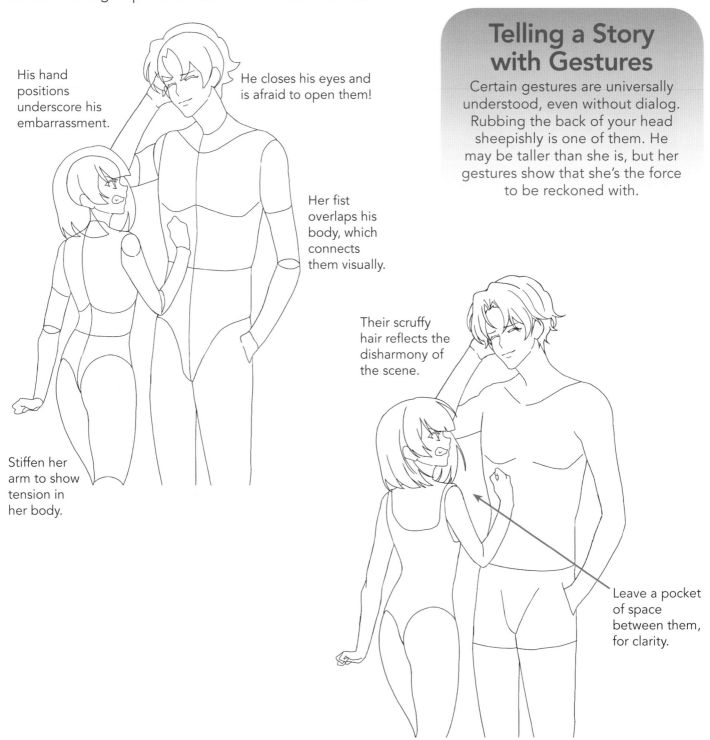

His hand positions underscore his embarrassment.

He closes his eyes and is afraid to open them!

Her fist overlaps his body, which connects them visually.

Stiffen her arm to show tension in her body.

Telling a Story with Gestures

Certain gestures are universally understood, even without dialog. Rubbing the back of your head sheepishly is one of them. He may be taller than she is, but her gestures show that she's the force to be reckoned with.

Their scruffy hair reflects the disharmony of the scene.

Leave a pocket of space between them, for clarity.

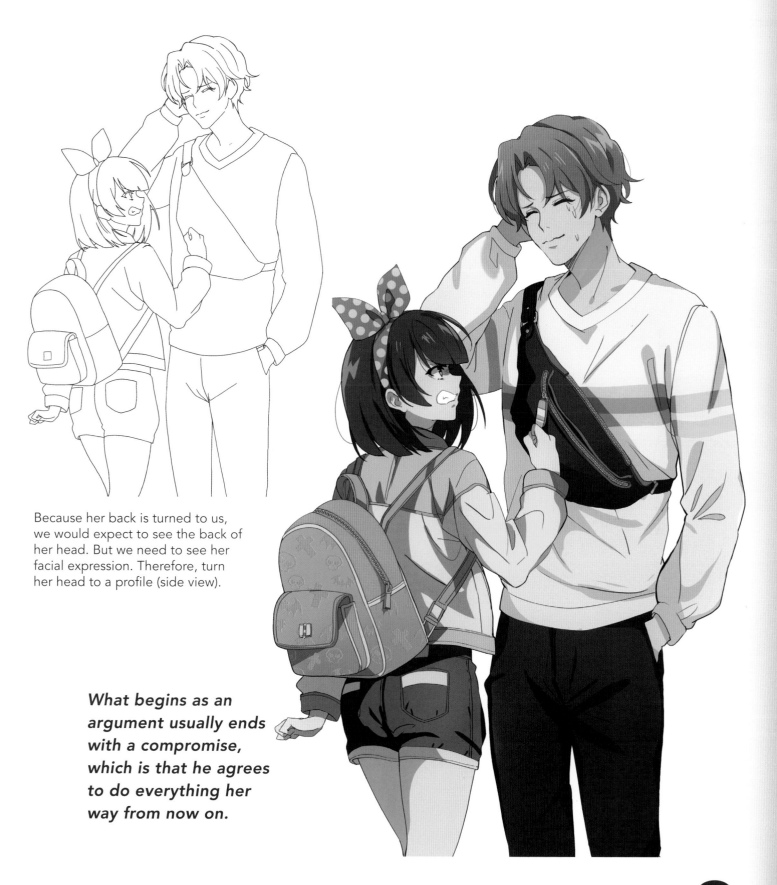

Because her back is turned to us, we would expect to see the back of her head. But we need to see her facial expression. Therefore, turn her head to a profile (side view).

What begins as an argument usually ends with a compromise, which is that he agrees to do everything her way from now on.

THE SILENT TREATMENT

Here's how the silent treatment works: Never leave his side and never smile. That's really all there is to it. The idea behind this weird strategy is that if she acts unhappy enough, he will have to cave.

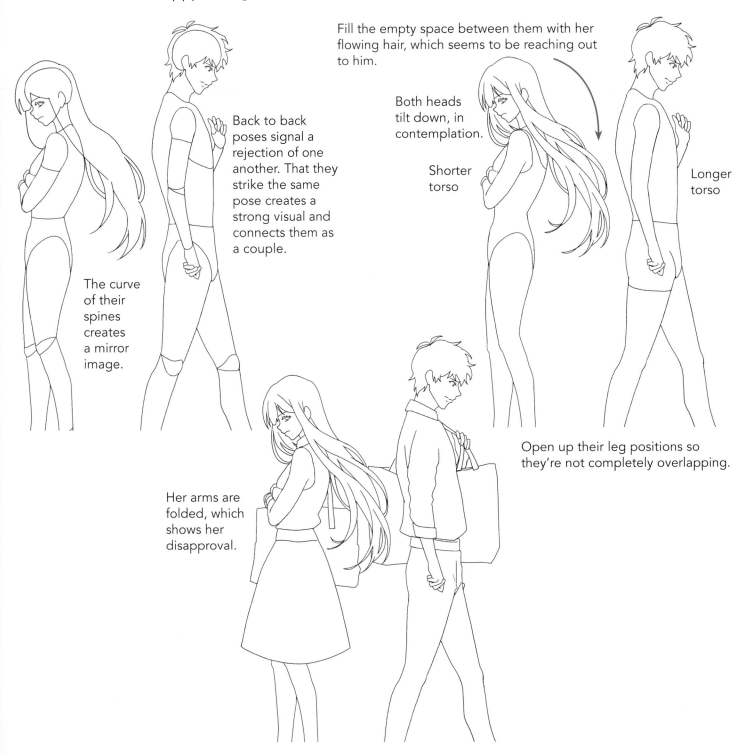

Fill the empty space between them with her flowing hair, which seems to be reaching out to him.

Back to back poses signal a rejection of one another. That they strike the same pose creates a strong visual and connects them as a couple.

Both heads tilt down, in contemplation.

Shorter torso

Longer torso

The curve of their spines creates a mirror image.

Open up their leg positions so they're not completely overlapping.

Her arms are folded, which shows her disapproval.

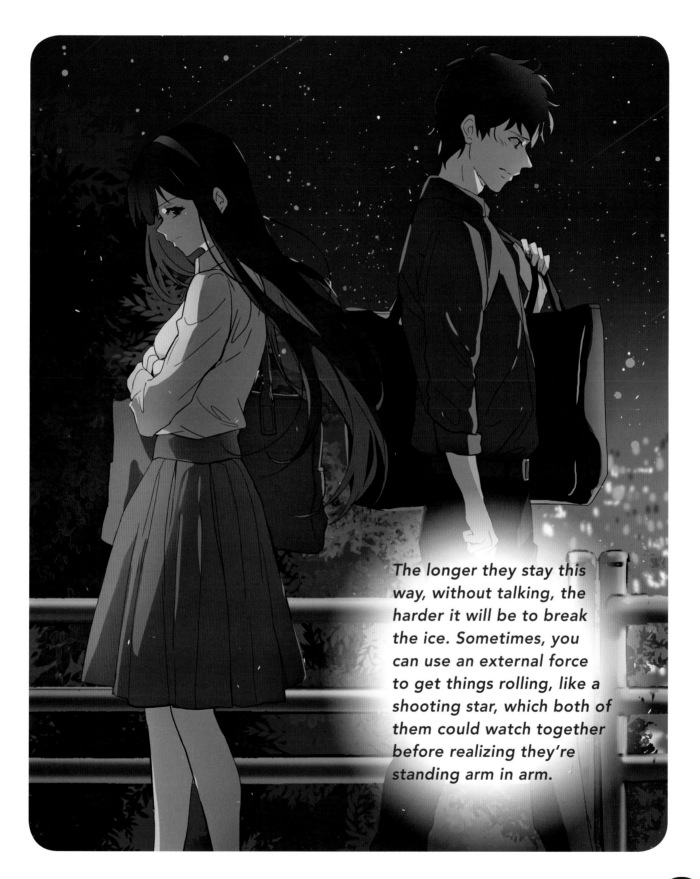

The longer they stay this way, without talking, the harder it will be to break the ice. Sometimes, you can use an external force to get things rolling, like a shooting star, which both of them could watch together before realizing they're standing arm in arm.

STOMPING OFF

This action is so typical among dating couples that it's almost a high school tradition. When drawing the "stomp off" motion, make it sudden. It usually occurs when one of them is in mid-sentence.

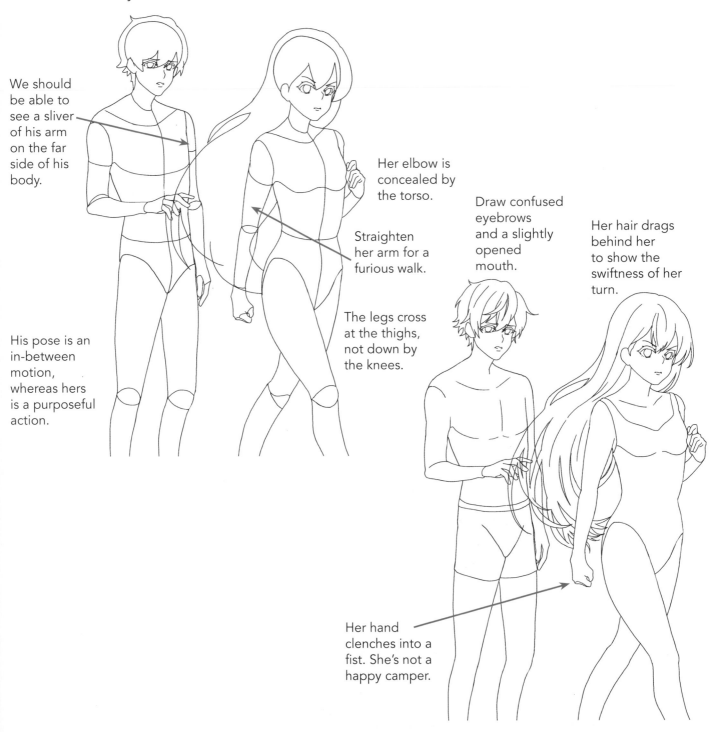

We should be able to see a sliver of his arm on the far side of his body.

His pose is an in-between motion, whereas hers is a purposeful action.

Her elbow is concealed by the torso.

Straighten her arm for a furious walk.

The legs cross at the thighs, not down by the knees.

Draw confused eyebrows and a slightly opened mouth.

Her hair drags behind her to show the swiftness of her turn.

Her hand clenches into a fist. She's not a happy camper.

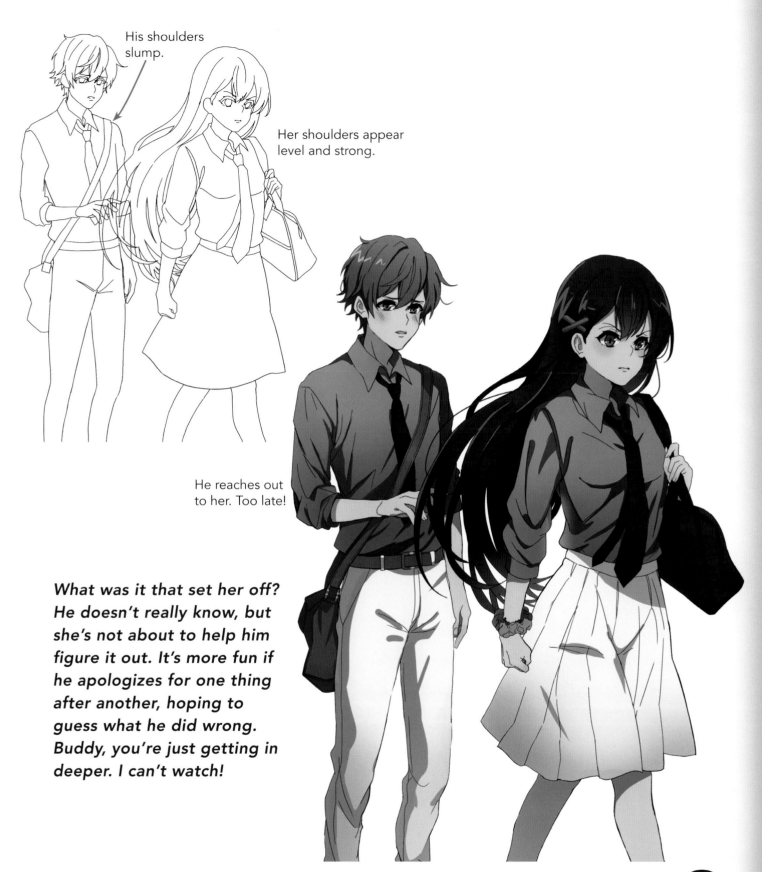

His shoulders slump.

Her shoulders appear level and strong.

He reaches out to her. Too late!

What was it that set her off? He doesn't really know, but she's not about to help him figure it out. It's more fun if he apologizes for one thing after another, hoping to guess what he did wrong. Buddy, you're just getting in deeper. I can't watch!

MAKING UP

Despite the obstacles and pitfalls of dating, some lucky couples will manage to stay together. As in real life, the secret to their success is the laughter that they share. The poses of characters that get along are relaxed, without tension in the body.

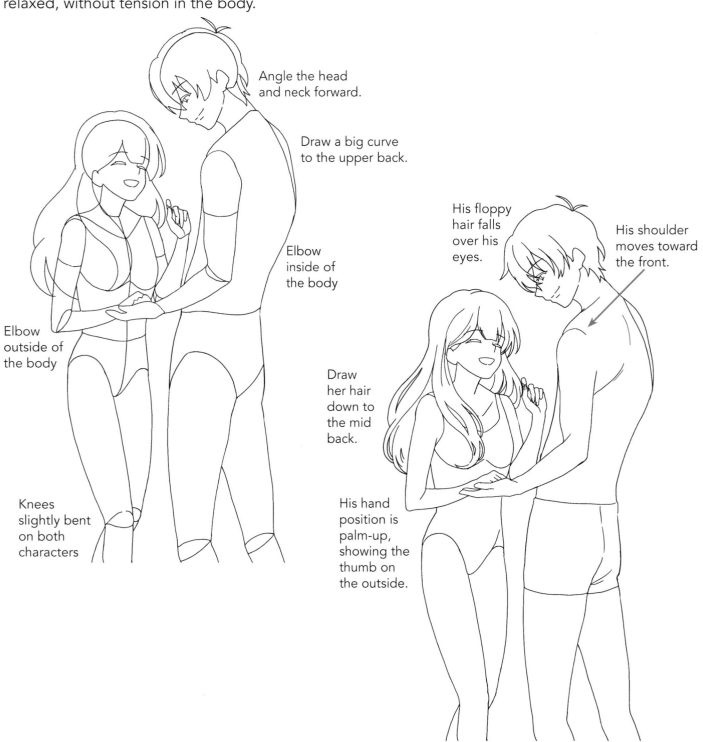

Angle the head and neck forward.

Draw a big curve to the upper back.

Elbow inside of the body

Elbow outside of the body

Knees slightly bent on both characters

His floppy hair falls over his eyes.

His shoulder moves toward the front.

Draw her hair down to the mid back.

His hand position is palm-up, showing the thumb on the outside.

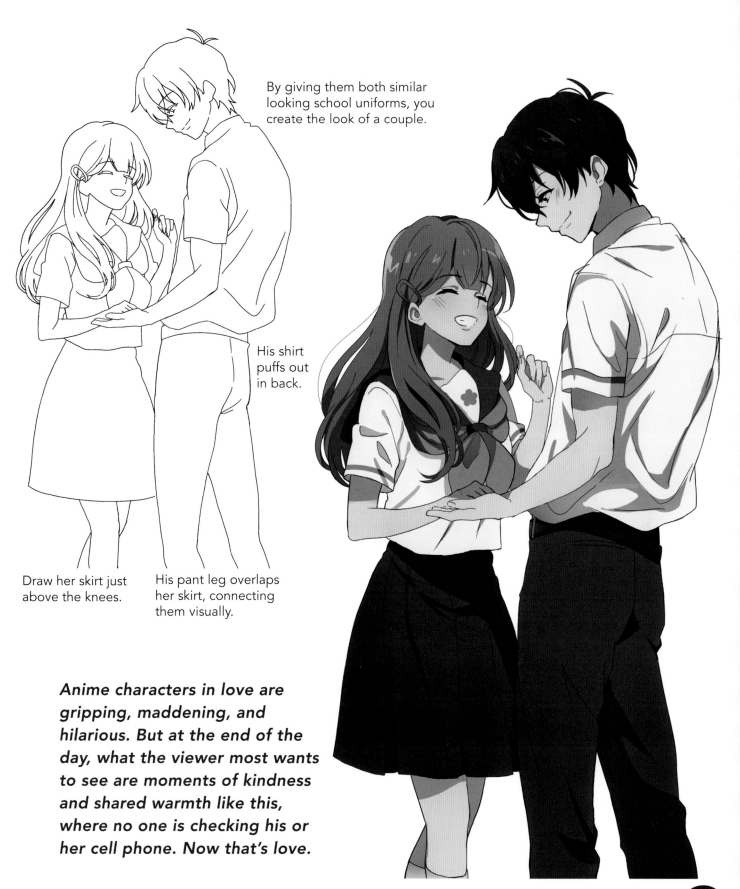

By giving them both similar looking school uniforms, you create the look of a couple.

His shirt puffs out in back.

Draw her skirt just above the knees.

His pant leg overlaps her skirt, connecting them visually.

Anime characters in love are gripping, maddening, and hilarious. But at the end of the day, what the viewer most wants to see are moments of kindness and shared warmth like this, where no one is checking his or her cell phone. Now that's love.

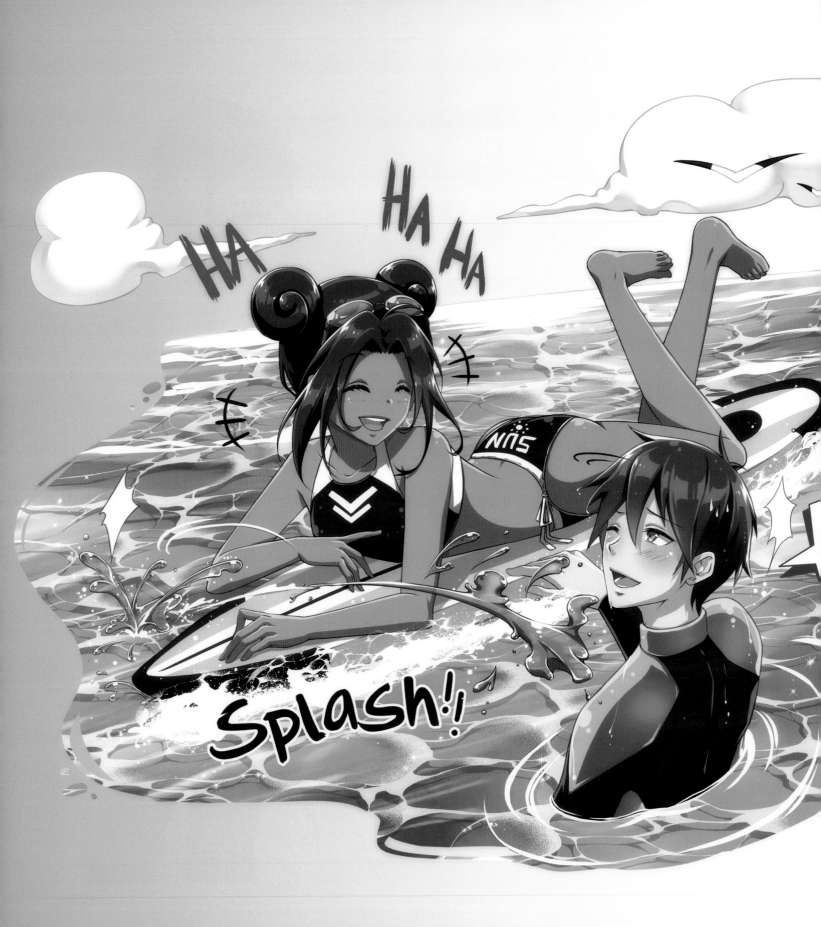

Drawing Simple Scenes

There are three basic principles to drawing scenes.
First, the viewer must instantly be able to identify the
location and what the people in it are doing. This
often requires a recognizable icon, in the way that
lockers identify a school hallway. Second, if a scene
is spread out evenly, it will lack interest. Therefore,
you'll generally want to cluster your characters in one
area of the page. Finally, you don't have to draw every
detail in order to create an effective background. In
fact, too much background detail can distract the
viewer. Always remember: When in doubt, simplify.

A Day at the Beach

The beach is a fun location for staging a date, but you still need to be inventive. Two people lying on towels aren't visually compelling. Instead, show your characters being active. They can play volleyball, fly drones, or take part in all sorts of water sports.

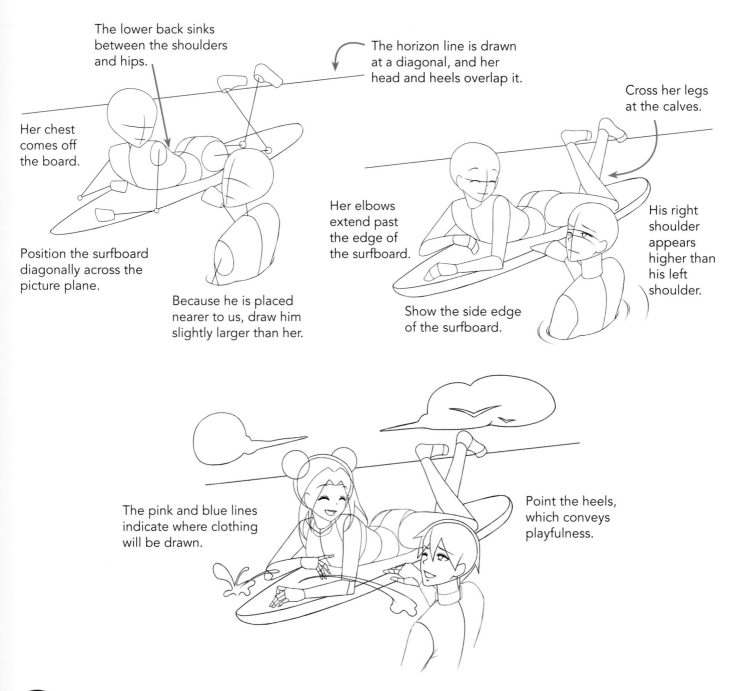

The lower back sinks between the shoulders and hips.

The horizon line is drawn at a diagonal, and her head and heels overlap it.

Cross her legs at the calves.

Her chest comes off the board.

Her elbows extend past the edge of the surfboard.

His right shoulder appears higher than his left shoulder.

Position the surfboard diagonally across the picture plane.

Because he is placed nearer to us, draw him slightly larger than her.

Show the side edge of the surfboard.

The pink and blue lines indicate where clothing will be drawn.

Point the heels, which conveys playfulness.

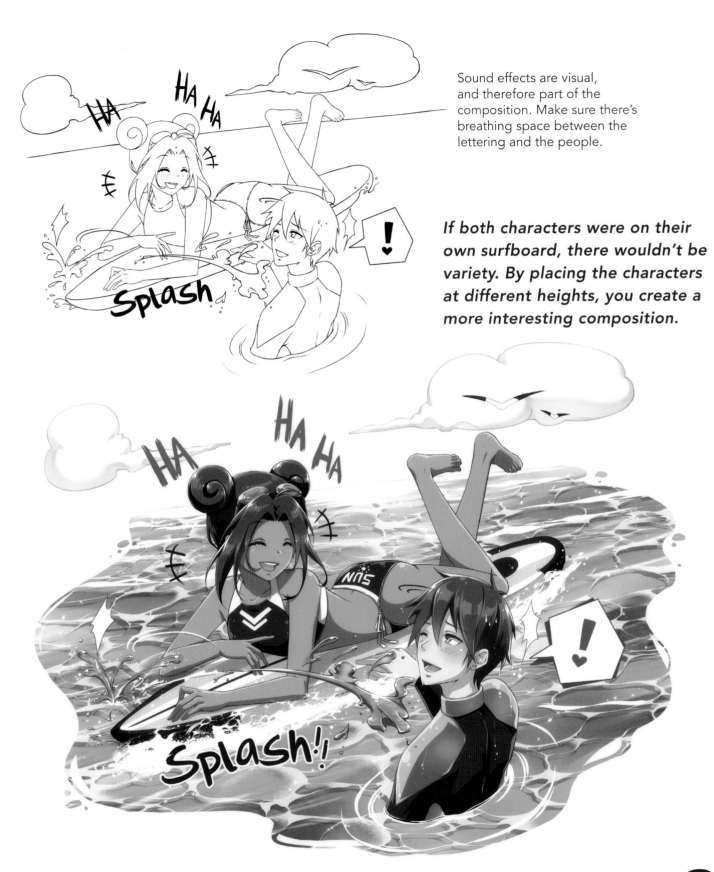

Sound effects are visual, and therefore part of the composition. Make sure there's breathing space between the lettering and the people.

If both characters were on their own surfboard, there wouldn't be variety. By placing the characters at different heights, you create a more interesting composition.

Bowling for Two

To create an effective composition, place the shorter character in front of the taller one. The boy is positioned to lean left, so that his face won't be blocked by hers. Little adjustments like these are necessary to maintain clarity when drawing a scene. The bowling ball dispenser, which diminishes toward the back of the scene, creates the look of depth.

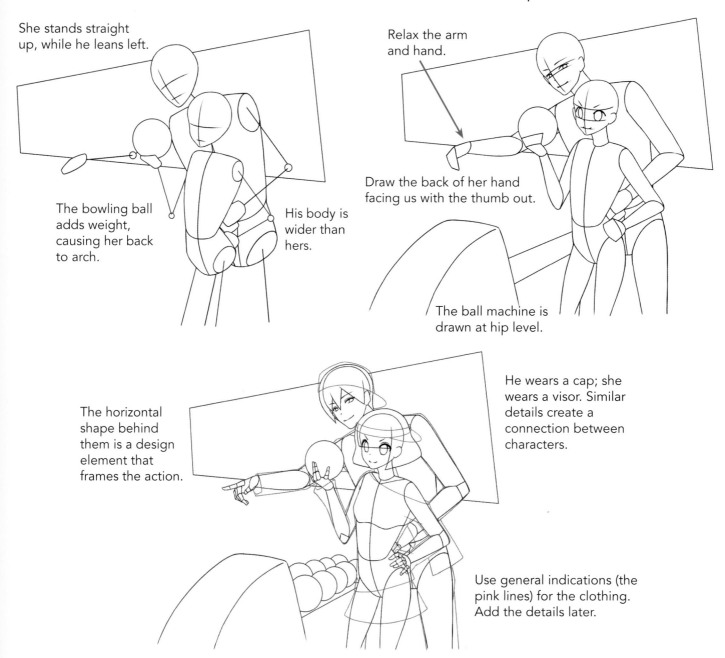

She stands straight up, while he leans left.

The bowling ball adds weight, causing her back to arch.

His body is wider than hers.

Relax the arm and hand.

Draw the back of her hand facing us with the thumb out.

The ball machine is drawn at hip level.

The horizontal shape behind them is a design element that frames the action.

He wears a cap; she wears a visor. Similar details create a connection between characters.

Use general indications (the pink lines) for the clothing. Add the details later.

Draw a sign.

Each ball
overlaps the
one behind it.

Draw a stylish
sweater off the
shoulder.

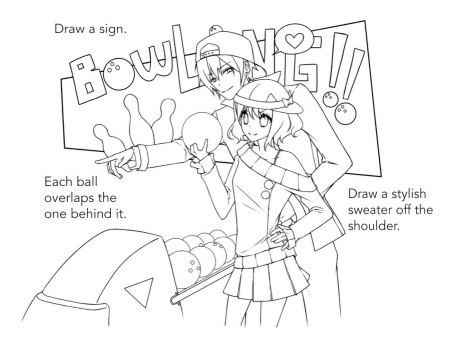

You can use color
to strengthen
the concept of
a scene. For
example, the boy
is trying to act
like the expert
bowler. To show
that idea, his outfit
matches the color
of the ball—purple.
But she'll be the one
who ends up stealing
the victory, so her
outfit should be more
dramatic than his:
black and red.

Picnic in the Park

She's so impressed! He brought everything for their picnic: three different flavors of soda and three sizes of chips. Fortunately, she brought the rest: bento boxes, cups, plates, napkins, a blanket, and a picnic basket. Notice that in each of these scenes, the couple is at the center of the composition, which draws the eye right to them. The background doesn't need to be fully drawn to each corner of the page. Just carve out your own little spot for the couple.

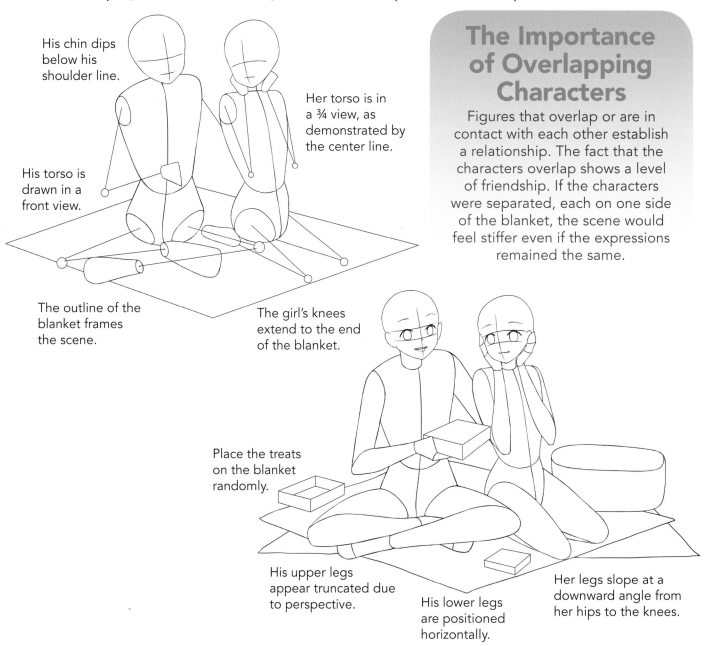

His chin dips below his shoulder line.

Her torso is in a ¾ view, as demonstrated by the center line.

His torso is drawn in a front view.

The outline of the blanket frames the scene.

The girl's knees extend to the end of the blanket.

Place the treats on the blanket randomly.

His upper legs appear truncated due to perspective.

His lower legs are positioned horizontally.

Her legs slope at a downward angle from her hips to the knees.

The Importance of Overlapping Characters

Figures that overlap or are in contact with each other establish a relationship. The fact that the characters overlap shows a level of friendship. If the characters were separated, each on one side of the blanket, the scene would feel stiffer even if the expressions remained the same.

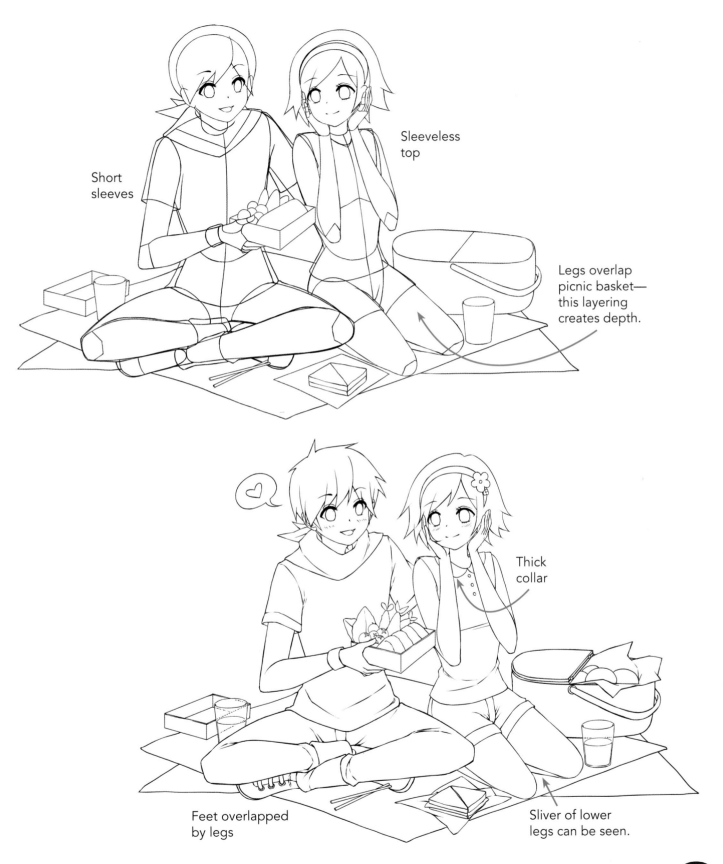

Short sleeves

Sleeveless top

Legs overlap picnic basket—this layering creates depth.

Thick collar

Feet overlapped by legs

Sliver of lower legs can be seen.

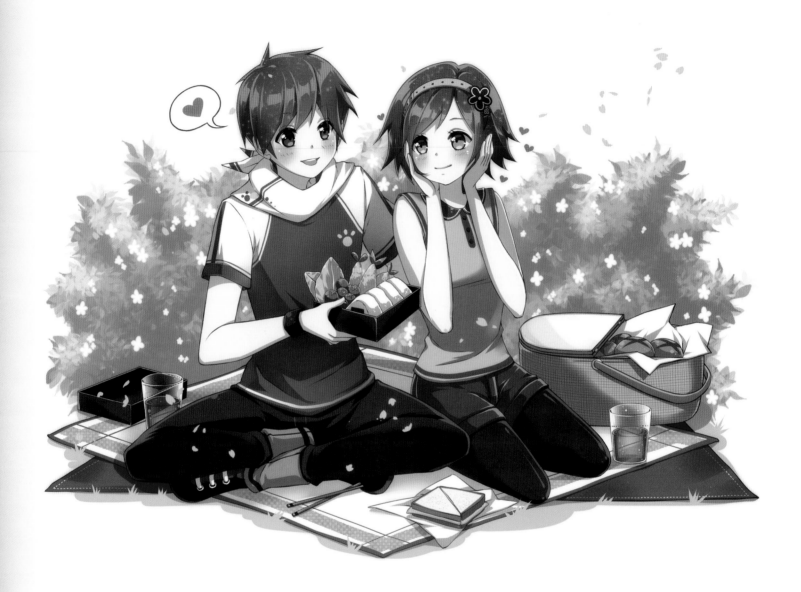

Let's observe a neat color trick being applied: By using magenta on the blanket, as well as in the boy's hair, you end up bracketing the image with the same color, which gives the scene a cohesive look.

Passing Notes

You'd think this guy could wait until class lets out to ask the girl to the prom, but that would be too easy. Instead, he's got to use the famous under-the-arm note passing technique. This requires deflecting attention from the teacher and 31 bored students who would like nothing more than to catch him in the act.

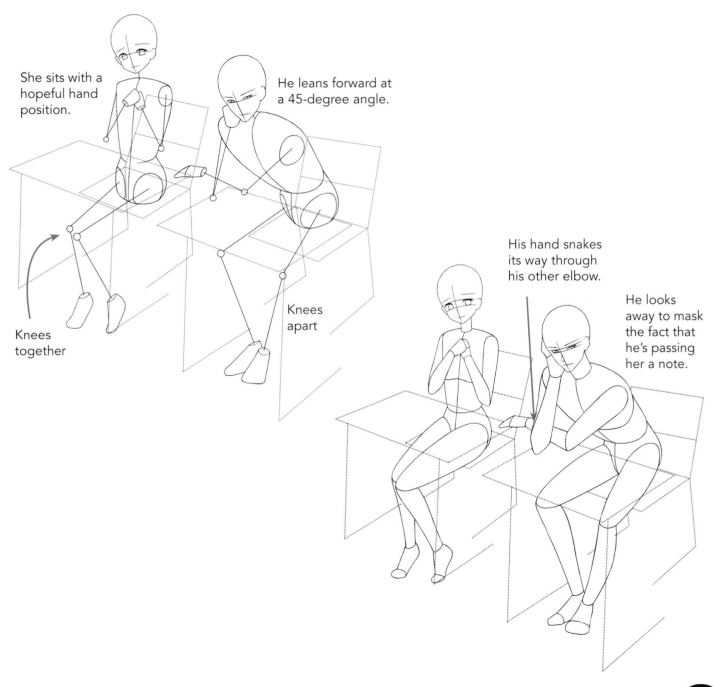

She sits with a hopeful hand position.

He leans forward at a 45-degree angle.

Knees together

Knees apart

His hand snakes its way through his other elbow.

He looks away to mask the fact that he's passing her a note.

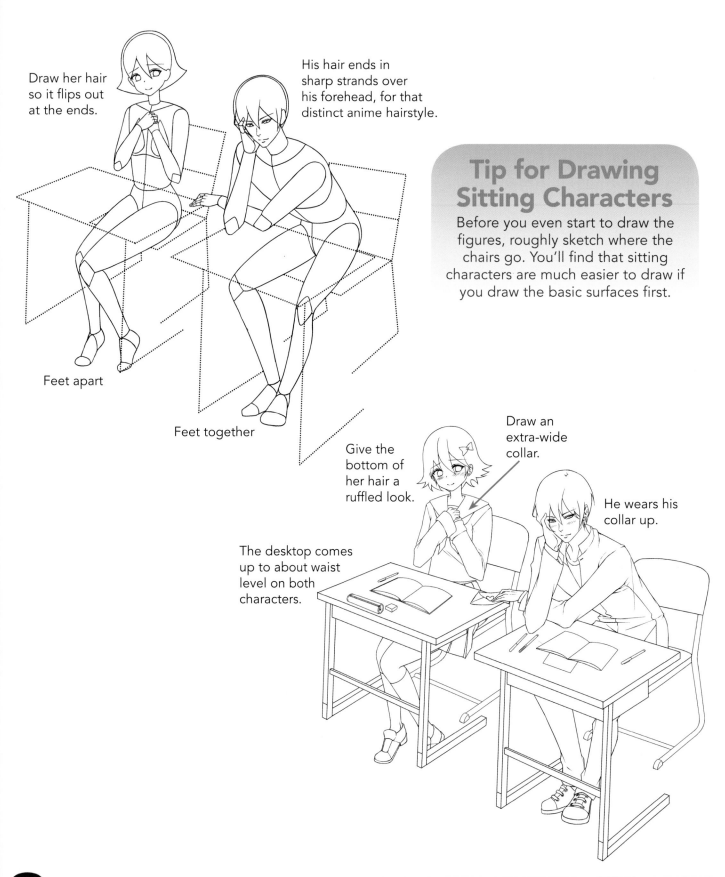

Draw her hair so it flips out at the ends.

His hair ends in sharp strands over his forehead, for that distinct anime hairstyle.

Feet apart

Feet together

Tip for Drawing Sitting Characters

Before you even start to draw the figures, roughly sketch where the chairs go. You'll find that sitting characters are much easier to draw if you draw the basic surfaces first.

Give the bottom of her hair a ruffled look.

Draw an extra-wide collar.

He wears his collar up.

The desktop comes up to about waist level on both characters.

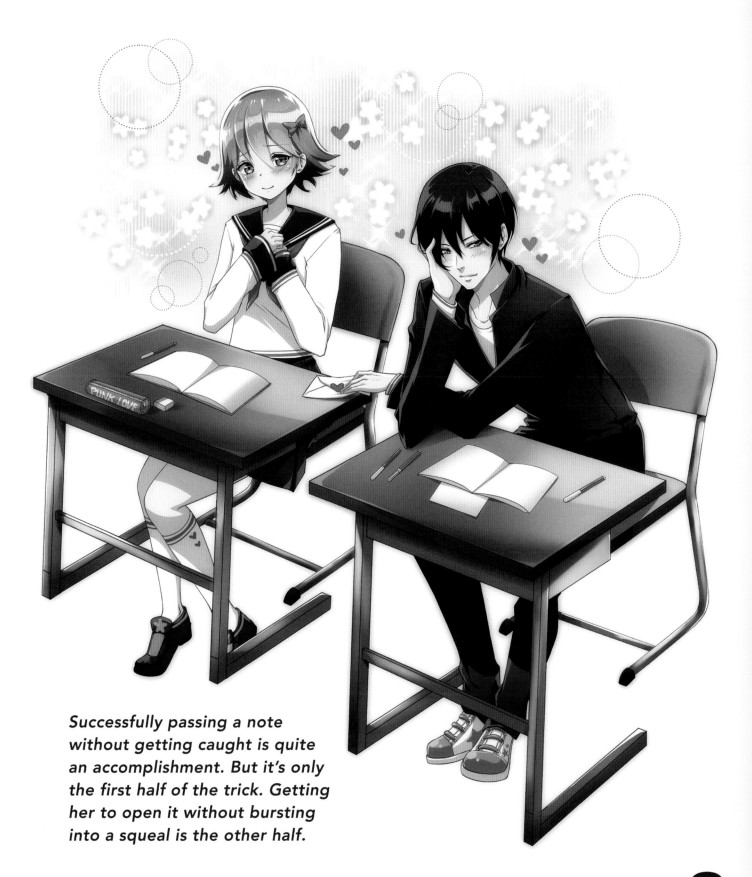

Successfully passing a note without getting caught is quite an accomplishment. But it's only the first half of the trick. Getting her to open it without bursting into a squeal is the other half.

Special Moments

What types of poses create memorable moments? Introverted poses generally work better than bold, extroverted ones. Generally, introverted poses are more dramatic for the romance genre.

CLASSIC COUPLE

Let's start with the classic hand-holding pose. Even though the foreheads touch, it's important to leave space between the characters so they read clearly.

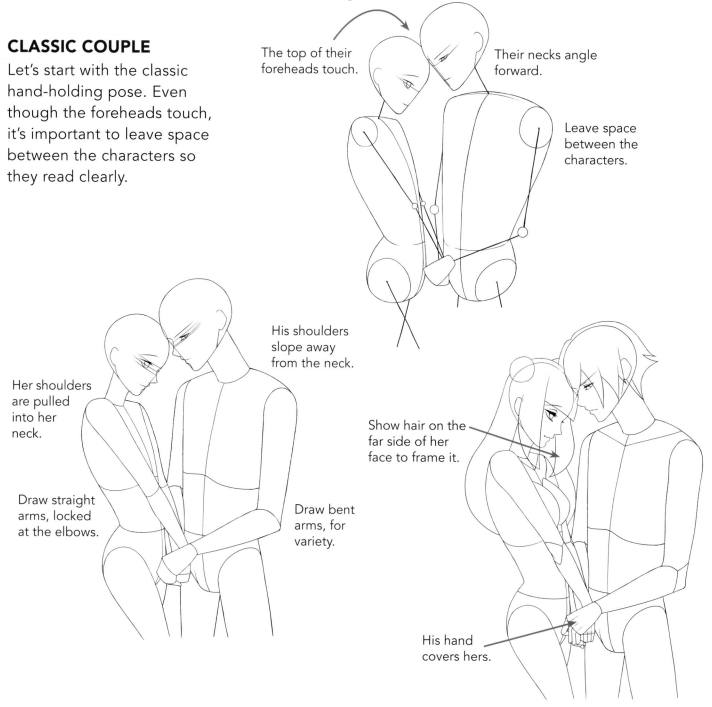

The top of their foreheads touch.

Their necks angle forward.

Leave space between the characters.

His shoulders slope away from the neck.

Her shoulders are pulled into her neck.

Draw straight arms, locked at the elbows.

Draw bent arms, for variety.

Show hair on the far side of her face to frame it.

His hand covers hers.

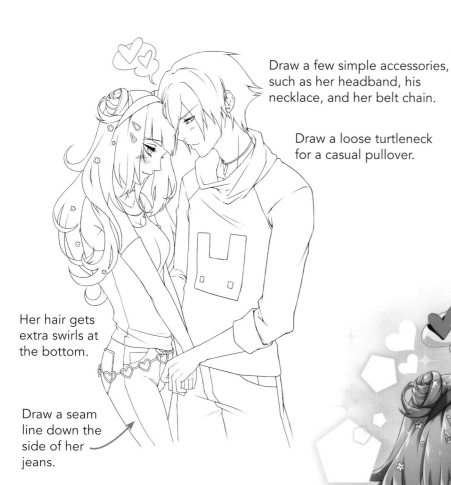

Draw a few simple accessories, such as her headband, his necklace, and her belt chain.

Draw a loose turtleneck for a casual pullover.

Her hair gets extra swirls at the bottom.

Draw a seam line down the side of her jeans.

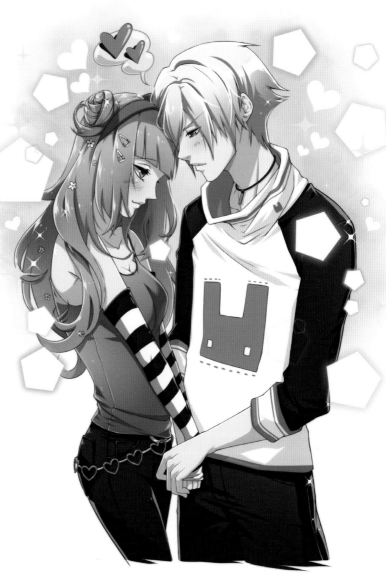

They share a color palette, which is black and white. Our lovestruck couple doesn't notice the special effects (pentagon shapes) all around them. They probably don't notice where they are either.

THE KISS

The first time a couple kisses is a big moment in a romance story. A lot could go wrong. One of them could develop a nervous case of the giggles. Or one could have just finished a plate of pasta with garlic sauce. Or one of them could suddenly develop a nervous case of the hiccups. But true love won't let any of that get in the way—except for maybe the garlic pasta. You've got to draw the line somewhere.

The taller character leans in further to reach the shorter character.

The front of her face slightly overlaps the front of his face.

You need to overlap one character's face with the other, or their noses will collide!

Generally, the lower back of females curves to a greater degree than it does on males.

Draw the shoulders down in a relaxed position, which makes the neck appear longer.

The upper back is drawn with a pronounced curve on both characters.

For both characters, the upper arms are positioned within the outline of the body.

Her ponytail flows all the way down her back.

His hand cups her elbow.

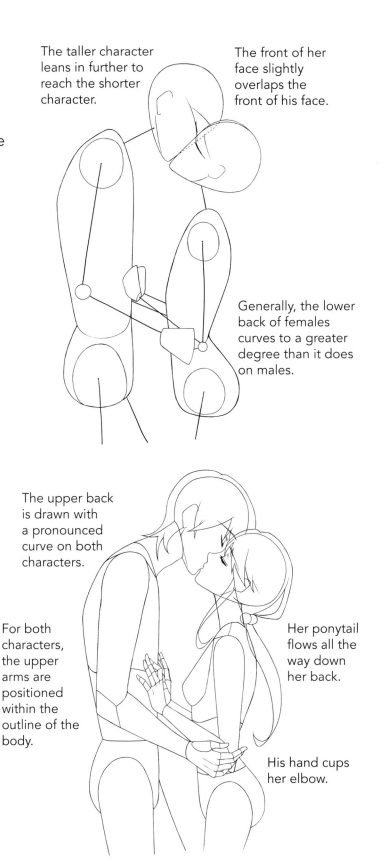

Draw the hair a little shaggy.

When the eyes are drawn in the closed position, emphasize the thickness of the eyelashes.

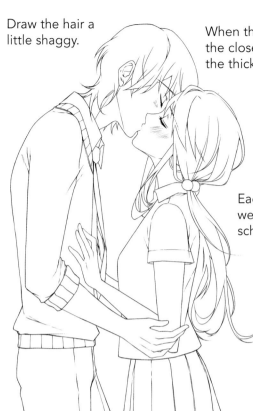

It's optional to add blush lines to the cheeks.

Each character wears a traditional school uniform.

Closed eyes, emphasize the eyelashes.

I'm pretty sure they're only going to give their homework a halfhearted effort tonight. I can just hear them now on the phone:
"You hang up first..."
"No you hang up first..."
"No you hang up first..."

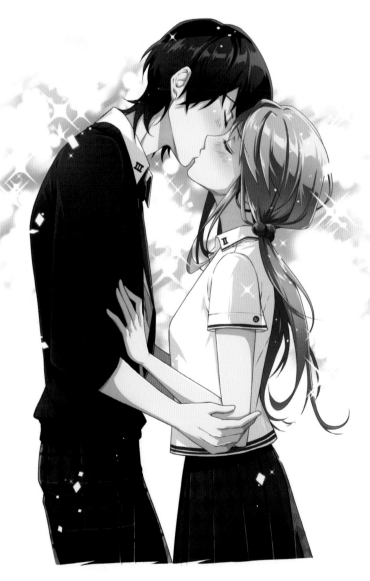

131

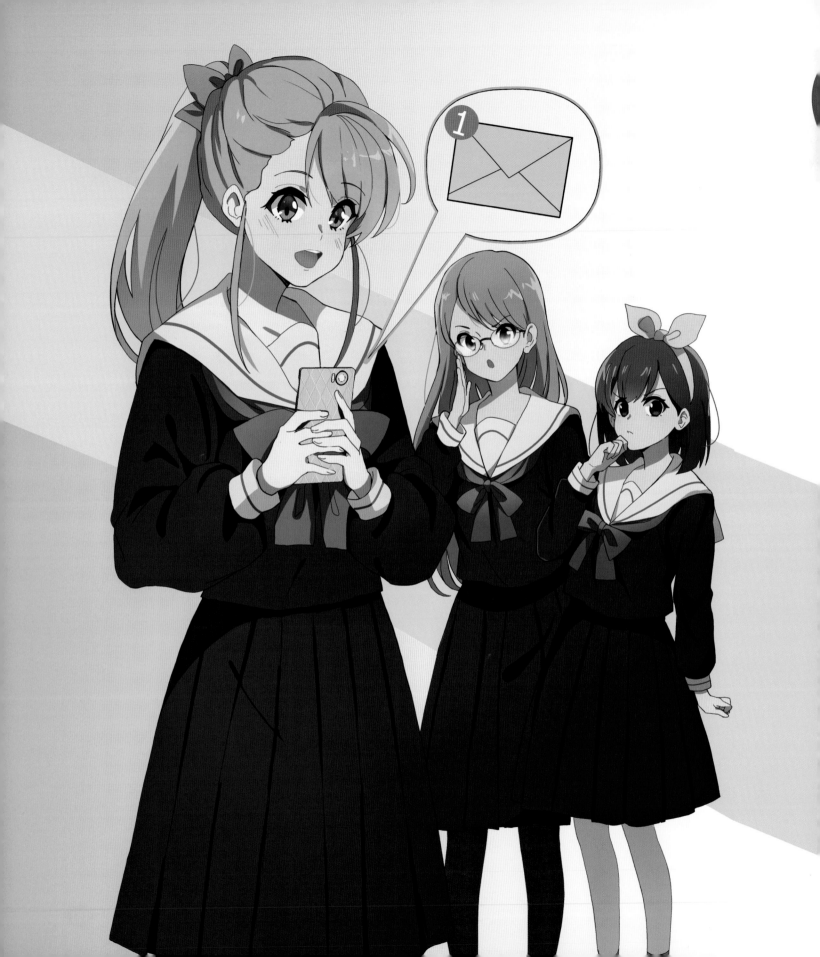

Environments and Effects

We can set up simple scenes to establish the mood of a character. Interestingly, viewers generally connect more strongly to a character whose mood is down rather than up. People have an instinctive empathy for someone in distress, unless, of course, you're a sociopath or a personal trainer. On the other end of the emotional spectrum, a character who laughs can brighten an entire scene. As you draw from this section, notice that the surroundings play an important role in creating the mood. In general, the environment for a happy person is sunny, whereas the environment for a forlorn person is overcast.

Rainy Day

The weather can become a factor in the romance genre. A sky full of rain is destiny's way of stacking the deck against your character. Raindrops are coming at him like projectiles. He just got dumped, but at least he still has his umbrella, which will soon to be hit by a mammoth gust of wind.

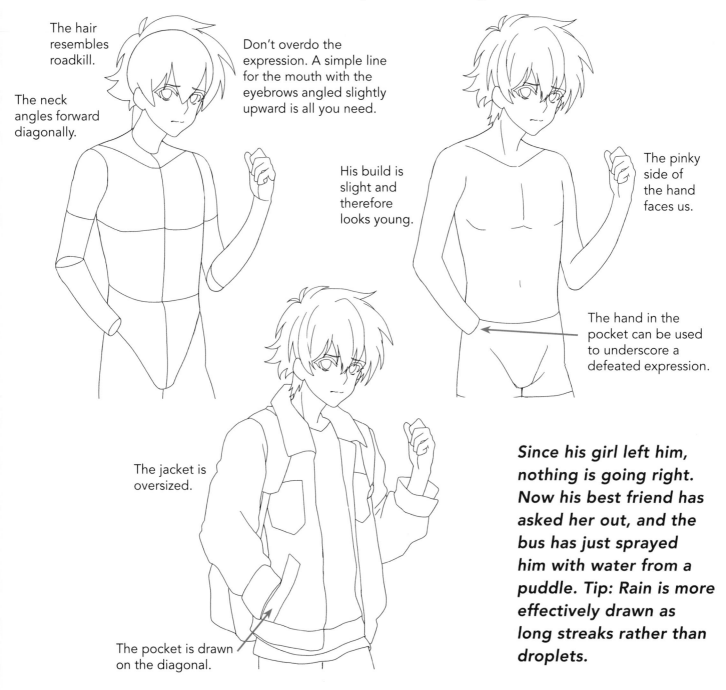

The hair resembles roadkill.

The neck angles forward diagonally.

Don't overdo the expression. A simple line for the mouth with the eyebrows angled slightly upward is all you need.

His build is slight and therefore looks young.

The pinky side of the hand faces us.

The hand in the pocket can be used to underscore a defeated expression.

The jacket is oversized.

The pocket is drawn on the diagonal.

Since his girl left him, nothing is going right. Now his best friend has asked her out, and the bus has just sprayed him with water from a puddle. Tip: Rain is more effectively drawn as long streaks rather than droplets.

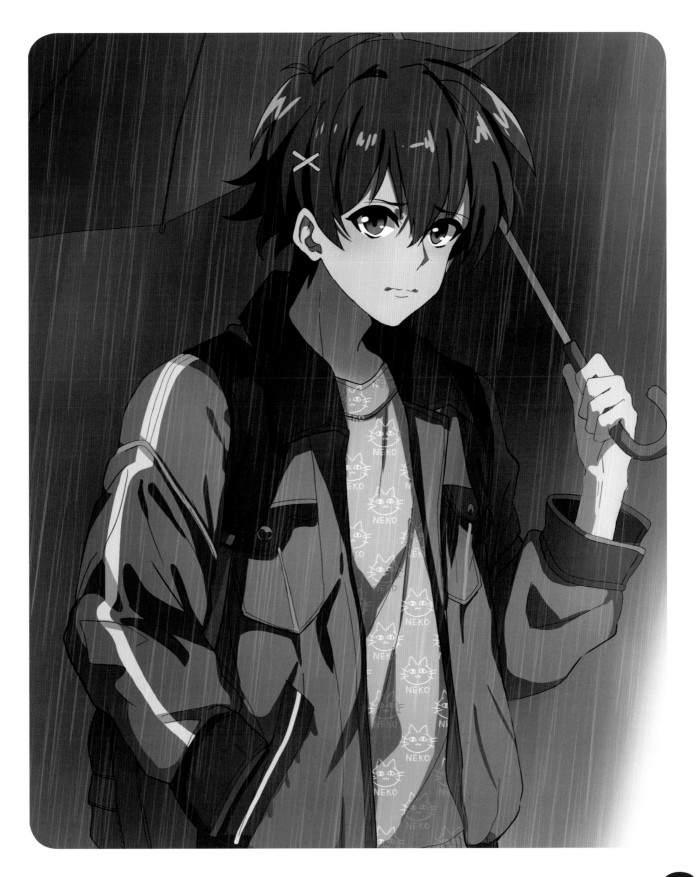

Fall Day

On the opposite side of a rainy day is a beautiful fall day. She just heard that her crush likes her. The sky is filled with a golden glow and autumnal shades of yellows and browns. Everything in her life is perfect and nothing will ever change. For five minutes.

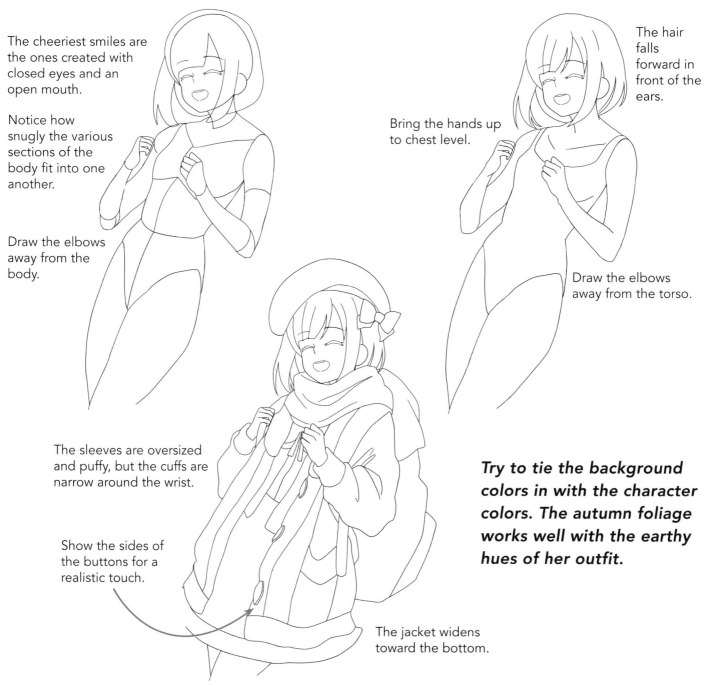

The cheeriest smiles are the ones created with closed eyes and an open mouth.

Notice how snugly the various sections of the body fit into one another.

Draw the elbows away from the body.

The hair falls forward in front of the ears.

Bring the hands up to chest level.

Draw the elbows away from the torso.

The sleeves are oversized and puffy, but the cuffs are narrow around the wrist.

Show the sides of the buttons for a realistic touch.

The jacket widens toward the bottom.

Try to tie the background colors in with the character colors. The autumn foliage works well with the earthy hues of her outfit.

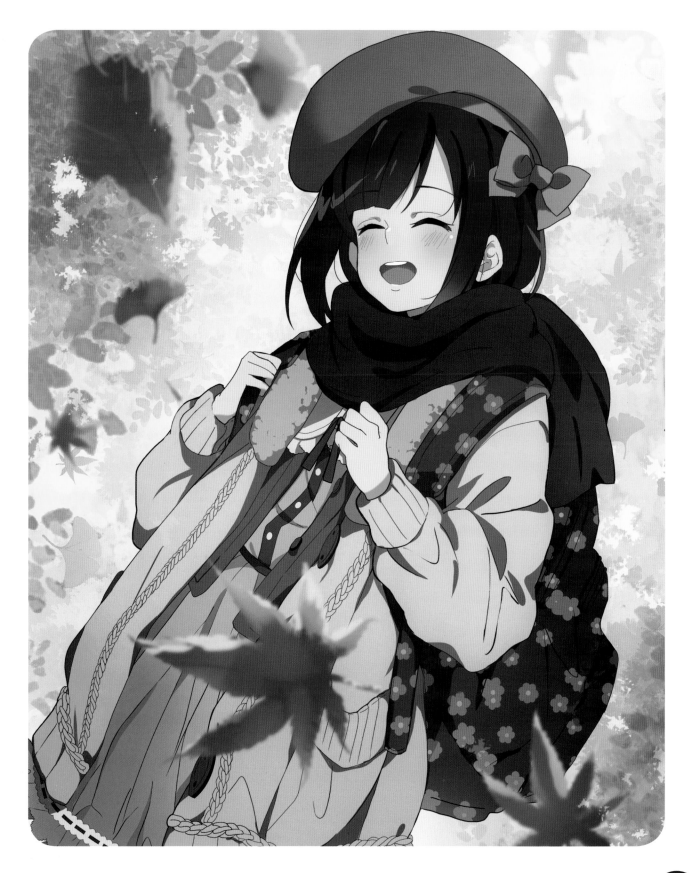

School

The school environment is established by the uniforms. The geometric color shape (yellow) becomes a background element that ties the characters together into a group. In this scene, a teenage girl is thrilled that the boy she likes just texted, but her two friends don't approve. Not off to a great start.

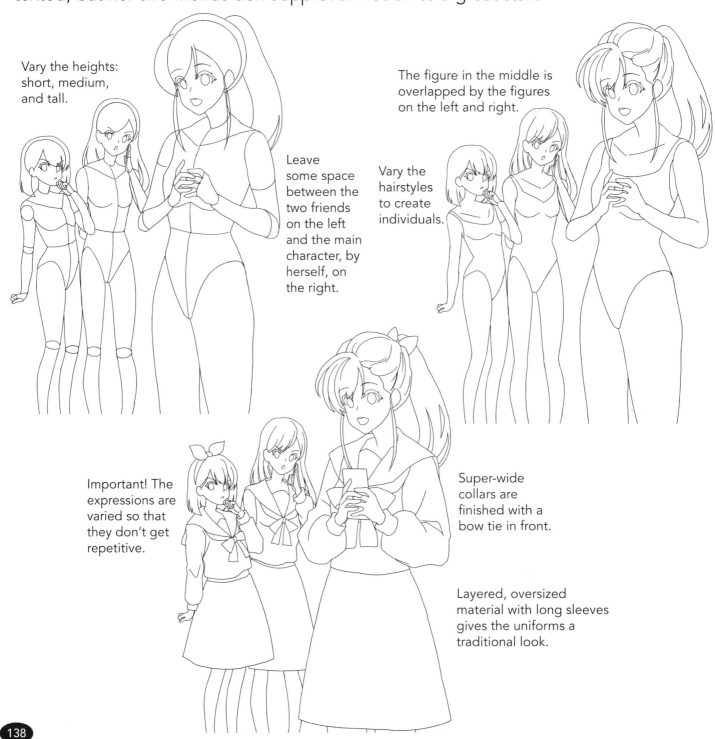

Vary the heights: short, medium, and tall.

Leave some space between the two friends on the left and the main character, by herself, on the right.

The figure in the middle is overlapped by the figures on the left and right.

Vary the hairstyles to create individuals.

Important! The expressions are varied so that they don't get repetitive.

Super-wide collars are finished with a bow tie in front.

Layered, oversized material with long sleeves gives the uniforms a traditional look.

Are her friends concerned for her because they don't trust her new boyfriend, or could they be a little bit jealous? You get to decide.

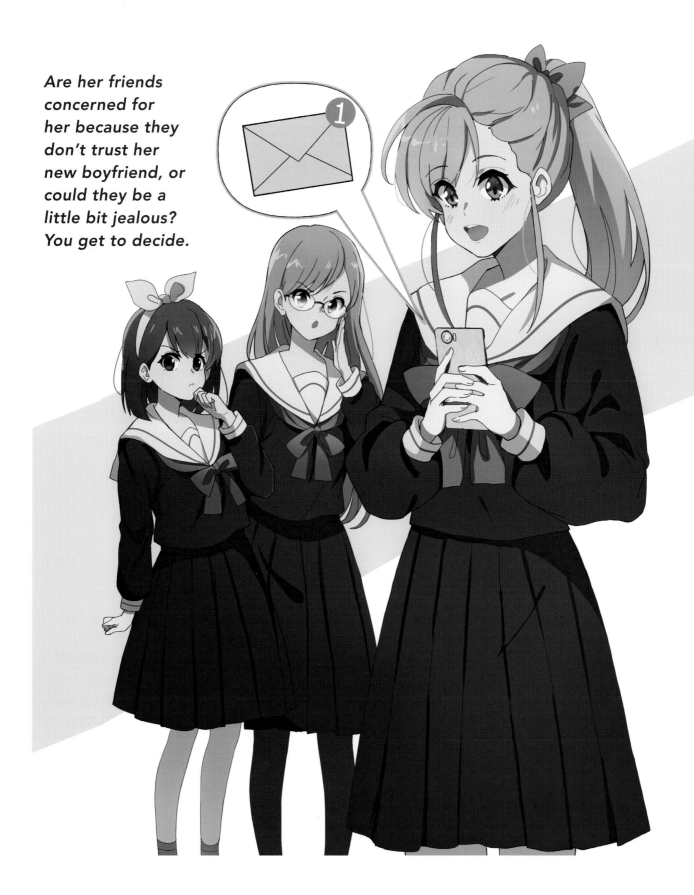

The Comfort of Home

When your friends have let you down, and you've got no one else to turn to, you can always rely on your pal with the floppy ears for unconditional love. Home is where you find your room, your dog, and a big bag of caramel corn hidden in the back of the pantry.

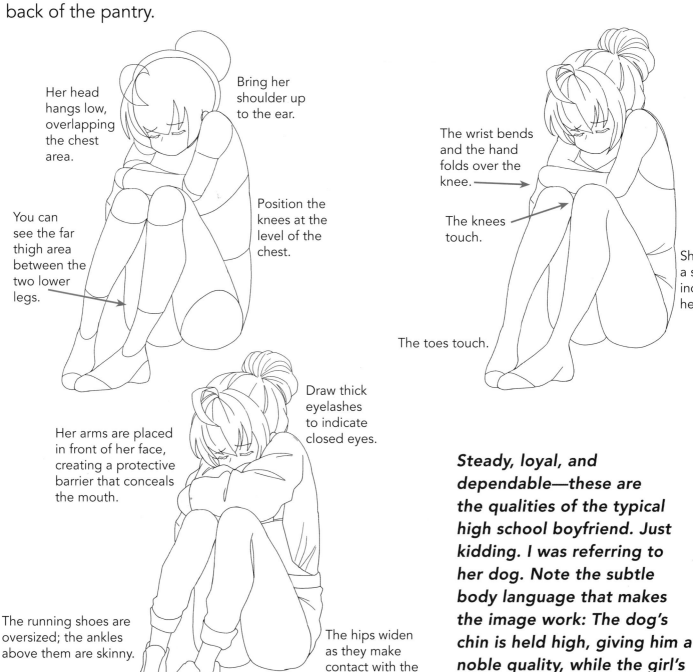

Her head hangs low, overlapping the chest area.

Bring her shoulder up to the ear.

You can see the far thigh area between the two lower legs.

Position the knees at the level of the chest.

The wrist bends and the hand folds over the knee.

The knees touch.

Show a slight indent at her waist.

The toes touch.

Her arms are placed in front of her face, creating a protective barrier that conceals the mouth.

Draw thick eyelashes to indicate closed eyes.

The running shoes are oversized; the ankles above them are skinny.

The hips widen as they make contact with the floor.

Steady, loyal, and dependable—these are the qualities of the typical high school boyfriend. Just kidding. I was referring to her dog. Note the subtle body language that makes the image work: The dog's chin is held high, giving him a noble quality, while the girl's head is low, showing sorrow.

140

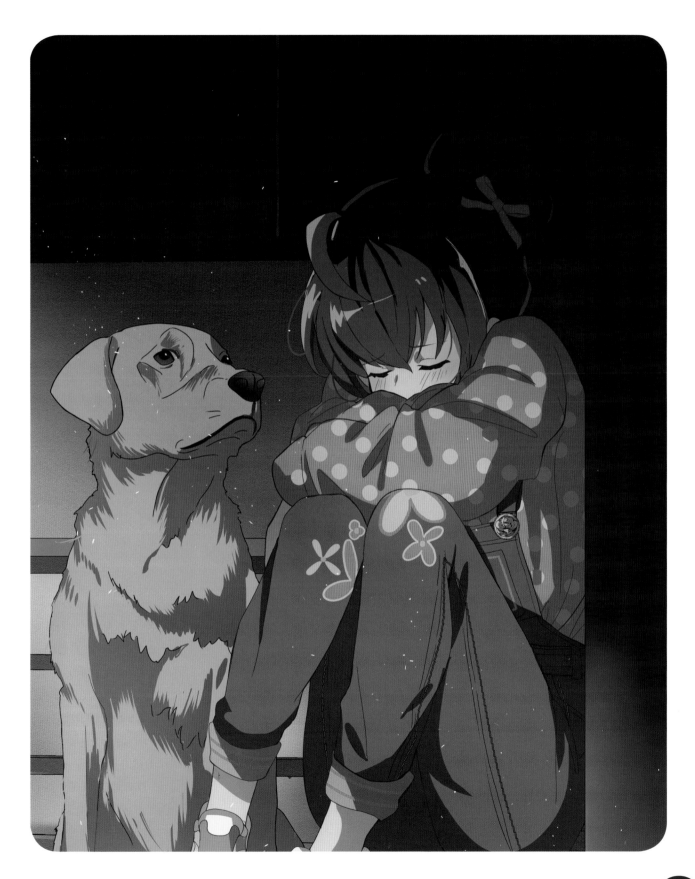

Plotting Revenge

Cross this character at your own risk. Any boy who dares to break up with her will see a touched up image of his face posted all over social media with a pirate scar and buck teeth. Vengeful characters are more entertaining if they're depicted as enjoying their nefarious deeds.

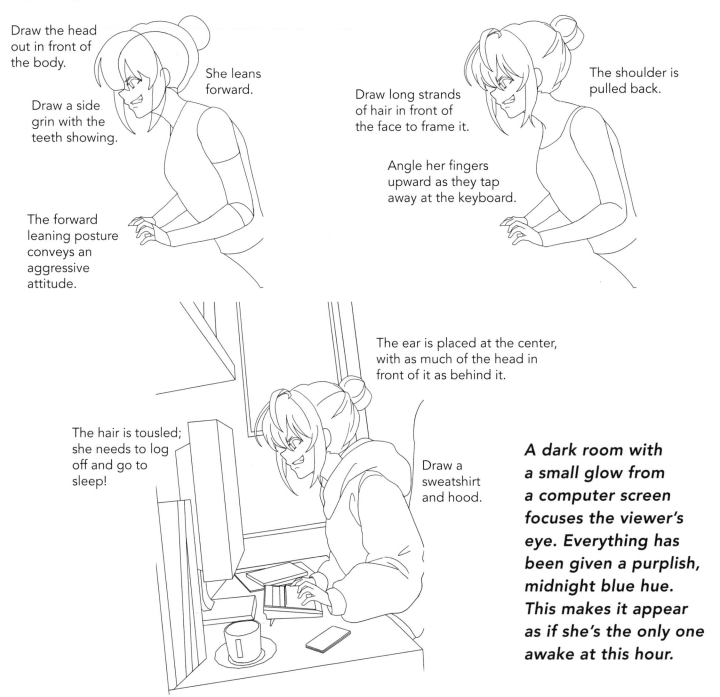

Draw the head out in front of the body.

Draw a side grin with the teeth showing.

The forward leaning posture conveys an aggressive attitude.

She leans forward.

Draw long strands of hair in front of the face to frame it.

Angle her fingers upward as they tap away at the keyboard.

The shoulder is pulled back.

The ear is placed at the center, with as much of the head in front of it as behind it.

The hair is tousled; she needs to log off and go to sleep!

Draw a sweatshirt and hood.

A dark room with a small glow from a computer screen focuses the viewer's eye. Everything has been given a purplish, midnight blue hue. This makes it appear as if she's the only one awake at this hour.

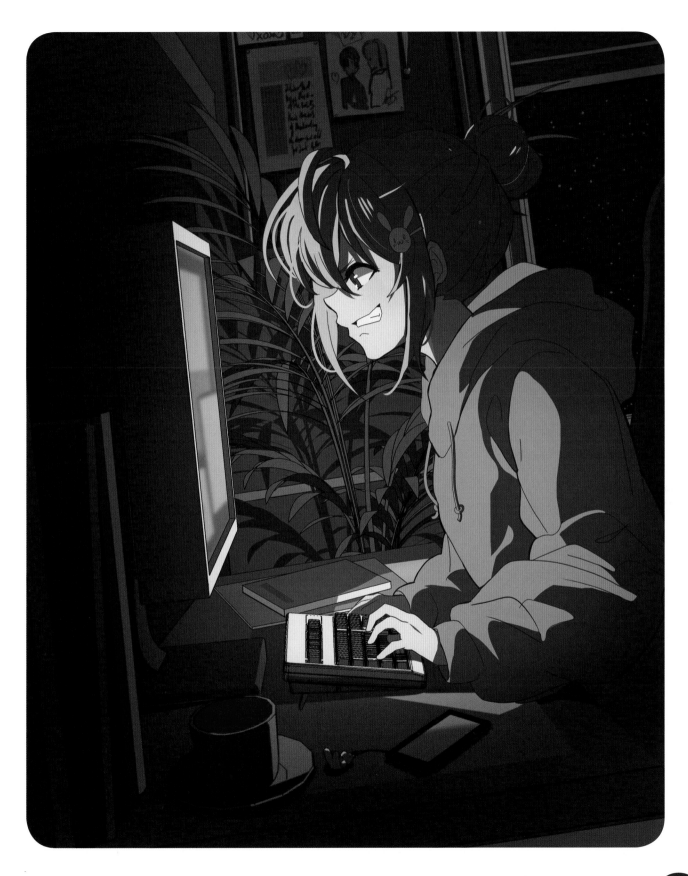

Index